BETTER PICTURE GUIDE TO
Flower & Garden
photography

RotoVision

A RotoVision Book
Published and Distributed by RotoVision SA
Rue Du Bugnon 7
1299 Crans-Près-Céligny
Switzerland

RotoVision SA, Sales & Production Office
Sheridan House, 112/116A Western Road
Hove, East Sussex BN3 1DD, England

Tel: +44 (0)1273 72 72 68
Fax: +44 (0)1273 72 72 69

Distributed to the trade in the United States by
Watson-Guptill Publications
1515 Broadway
New York, NY 10036

ISBN 2-88046--326-2

Book design by Brenda Dermody

Production and separations in Singapore by
ProVision Pte. Ltd.
Tel: +65 334 7720
Fax: +65 334 7721

BETTER PICTURE GUIDE TO

Flower & Garden
photography

MICHAEL BUSSELLE

Contents

Composing the Image	6		**Light & the Image**	78
Choosing a Viewpoint	8		Shooting in Sunlight	80
Using Shapes & Patterns	14		Controlling Contrast	82
Emphasising Texture	18		Shooting on Cloudy Days	84
Framing the Image	22		The Time of Day	86
Using Perspective	28		Light & Colour	88
Colour & Design	32		The Weather	92
Close-up Photography	36		The Seasons	94
The Subject	40		**Cameras & Equipment**	100
Borders & Shrubs	42		Choosing a Camera	102
Garden Landscapes	46		Choosing Lenses	106
Gardens & Architecture	50		Camera Accessories	108
Water Features	54		Apertures & Shutter Speeds	110
Arranged Flowers	58		Understanding Exposure	114
Garden Portraits	60		Choosing Film	118
Trees & the Woodland Garden	66		Using Filters	120
Ornaments & Details	68		Photographs for Pleasure & Profit	122
The Vegetable Garden	72			
Plants & Flowers in the Wild	74		**Glossary**	126

Composing the Image

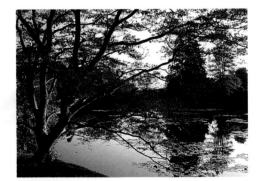

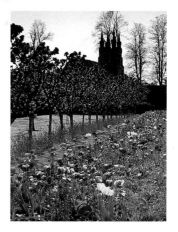

1

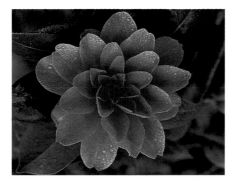

The way in which the main points
of interest in a scene are
arranged within the viewfinder determines how effective the resulting
photograph will be. This chapter shows how these key elements can be readily
identified and explains the methods you can use to
emphasise them.

Choosing a Viewpoint

The choice of viewpoint is central to the composition of an image and one of the most important decisions a photographer must make. When photographing gardens, remember that they have been designed with certain viewpoints in mind. Although this should by no means restrict your choice of camera angles, it is well worth taking into account.

Seeing

This ornate iron screen set into the stone archway caught my eye as I walked towards the rose garden.

Thinking

The garden beyond was in full sunlight and the archway was in shade, and I thought that the darker foreground shape would create an effective frame for a picture of the garden, as well as creating a heightened sense of depth.

Acting

My first thought was to shoot the archway front-on so that its shape was symmetrical. But from that viewpoint the pinnacle of the iron screen coincided with the top of the tree and the two details became confused. Also, from here the highlighted statue was right on the edge of the arch and became a distraction instead of a strong feature. I moved a few feet to my right which avoided these two problems and presented a more pleasing perspective of the archway.

Leeds Castle gardens near Maidstone in Kent, UK.

This shot appealed to me as the clumps of daffodils were in a pool of shade and the darker area of grass behind them acted as an effective background, making them seem even brighter. I chose a viewpoint which allowed me to place a section of the rustic wooden fence behind them to add a further element to the composition.

Technical Details
6 x 4.5cm SLR camera with a 105–210mm zoom lens and 81B warm-up filter; Fuji Velvia.

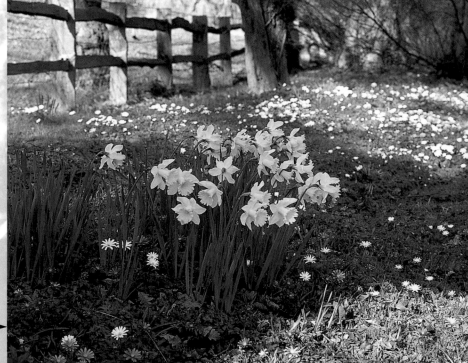

▼ 35mm SLR camera with a 20–35mm zoom lens,
polarising and 81C warm-up filters; Fuji Velvia.

Rule of Thumb

When looking for a viewpoint it's
worth looking behind you as well
as towards your subject as, in this
way, you will sometimes find
objects which can be used
effectively as foreground interest.

Hever Castle Gardens near
Edenbridge in Kent, UK.

Here you can see how this subject
would have appeared from a more
front-on viewpoint.

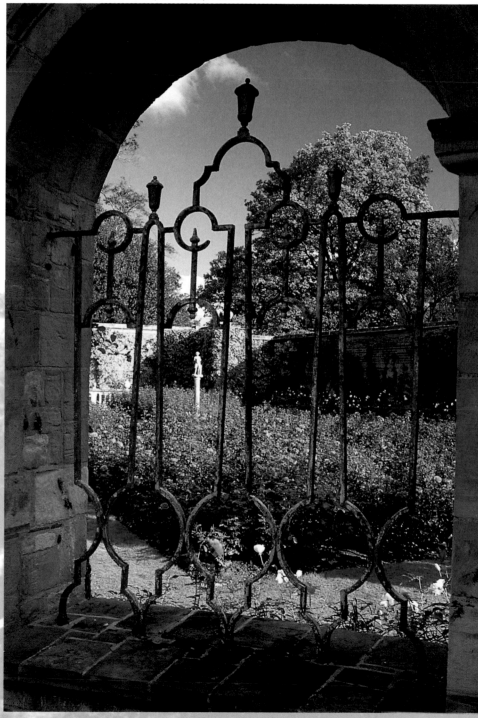

Choosing a Viewpoint

Seeing

These gardens depend for their appeal upon the striking geometric design of the borders, and this was most obvious as I approached them initially from a high viewpoint.

Thinking

I thought that this would be the most effective viewpoint for the picture I wanted and made my first exposure from this position using a wide-angle lens to include as much of the garden design as possible.

Acting

As I walked down the steps towards the garden level I could see how effective a lower viewpoint could also be. Using the same lens from a position close to the edge of the border, the shape created by the exaggerated perspective became quite extreme and the curving pathway produced a strong sense of depth and added a powerful element to the composition. Although this image is less informative about the nature of the garden, and its pattern, I feel that it is more striking graphically.

Technical Details ▶
▼ 6 x 4.5cm SLR camera with a 35mm lens and 81B warm-up filter; Fuji Velvia.

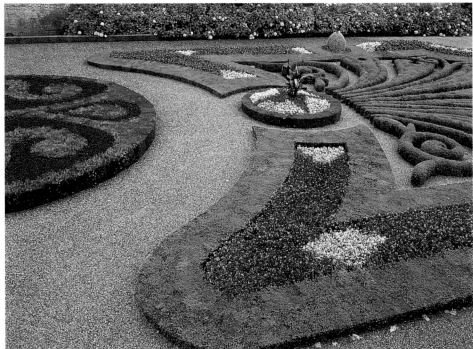

The Gardens of the Palais de la Berbie at Albi in the Tarn, France.

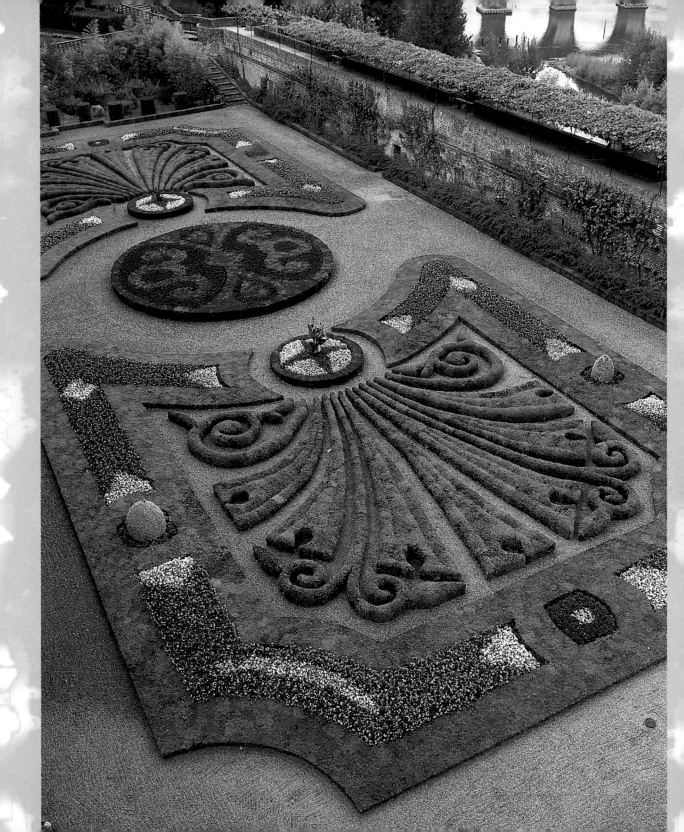

Choosing a Viewpoint

Seeing

The bold contrast between the blue sky and the red of the fuchsias, and the stark, textural quality of the statue were the most dominant features of this scene, shot by Julien Busselle, and he looked at various angles from which these elements would be most strikingly juxtaposed.

Thinking

Julien decided to use a close viewpoint which would enable him to fill the frame with as much colour and texture as possible and, at the same time, would allow him to shoot upwards towards the statue and make use of the sky as a background which has helped to keep the image quite simple and uncluttered.

Acting

To maximise the intensity of the blue sky and to enhance the colour saturation of the fuchsia blooms, Julien used a polarising filter and a small degree of underexposure.

Technical Details
▼ 6 x 4.5cm SLR camera with a 105–210mm zoom lens and 81C warm-up filter; Fuji Velvia.

Marle Place, Brenchley in Kent, UK.

The viewpoint needed for this picture by Julien Busselle was very precise as the focus of the composition was the curiously shaped topiary framed inside the hedge's archway together with the small splash of red. He framed the shot so that the remainder of the image was restricted to green shapes and textures and used an 81C warm-up filter to counteract the potential blue cast caused by midday summer sunlight.

Tapeley Park, Instow in
North Devon, UK.

◄ <u>Technical Details</u>
6 x 4.5cm SLR camera
with a 55–110mm zoom
lens and polarising filter;
Fuji Velvia.

Technique

It's important to
appreciate that the
**choice of
viewpoint** will
also affect the lighting
quality of a subject.
Sometimes either this
decision will have to be
a compromise or you
will need to return to a
specific viewpoint at a
**different time
of day** when the
light is directed from a
more effective angle.

Using Shapes & Patterns

All photographs depend for their effect on a number of individual visual elements. The most successful are usually those in which one or more of these elements is boldly and clearly defined. The outline or shape of a subject is the element which usually first identifies it, and a photograph with a dominant shape invariably has a strong initial impact.

Seeing

The vivid colour of these asters created a strong impact which was heightened by the boldly contrasting yellow centres of the flowers. The clump of flowers was quite extensive and unruly and my first attempts to photograph the blooms were hindered by the presence of too many which had passed their best.

Thinking

I realised that I was more likely to produce a pleasing image if I was very selective and framed the image tightly to exclude all but the most pristine blooms. By doing this I was also able to instil a strong sense of pattern and order in the image.

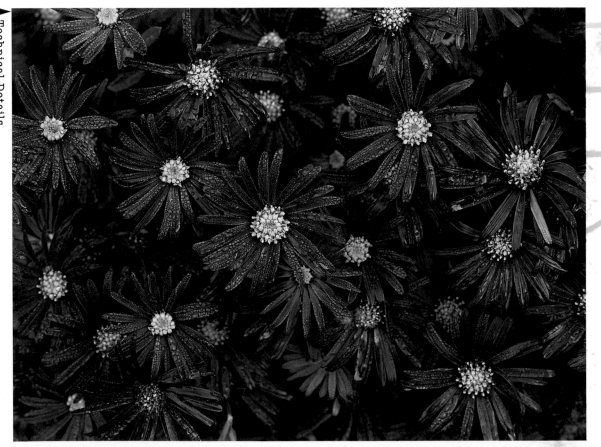

Technical Details
6 x 4.5cm SLR camera with a 55–110mm zoom lens and an extension tube; Fuji Velvia.

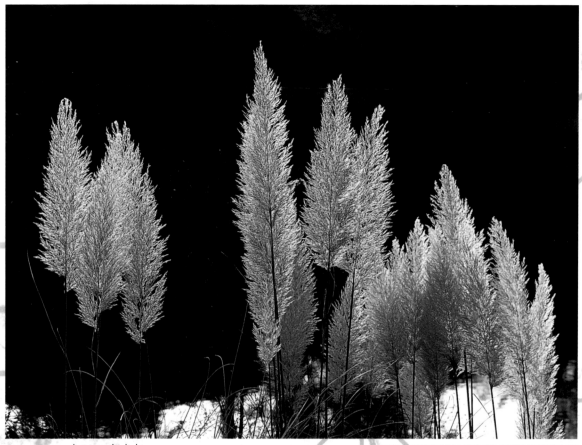

Pampas grass, shot into the light.

I shot this picture of pampas grass directly into the light late on an autumn day which has highlighted their bold shapes against the deeply shaded background. The sun was so low, however, that it created strong lens flare and I had to shield the lens to avoid this problem. I have a useful home-made gadget for this created from a flexible arm, a bulldog clip and a piece of black plastic.

My lens shield device.

Acting

I fitted an extension tube between my zoom lens and the camera which gave me a great deal of flexibility in choosing the distance between the camera and subject and the number of blooms to include in the frame. I set a small aperture of f16 which required a shutter speed of 1/4 second and had to wait until the slight breeze, which was ruffling the flowers, momentarily dropped before making the exposure.

Using Shapes & Patterns

Seeing

Although it was the rich, back-lit colours of the tulips which first attracted me to this scene, I was intrigued by the way the lighting had also created a striking silhouette of the distant village church and the trees surrounding it. The effect of the back lighting on the spring foliage of the fruit trees was also enhanced because they were juxtaposed against the almost-black background.

Thinking

I found a viewpoint which enabled me to place the border in the foreground leading away towards the church and used my zoom lens on a wide setting to include as much foreground as possible.

Acting

I chose a small aperture to ensure that both close and distant details were sharp and used a neutral-graduated filter to help retain some tone in the sky. Shooting into the light made it necessary to use a lens shield to prevent flare.

Technical Details

▼ 35mm SLR camera with a 35–70mm zoom lens and an extension tube; Fuji Velvia.

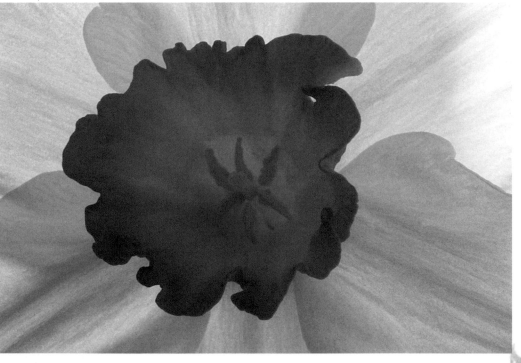

Close-up shot of a daffodil.

I was struck by the bold shape the orange centre of this daffodil created against the paler yellow of its petals, which the strong back lighting emphasised, and decided to make this the main feature of the shot. I used an extension tube to allow me to focus closely enough to exclude all but the petals from the image and used a small aperture to ensure adequate depth of field.

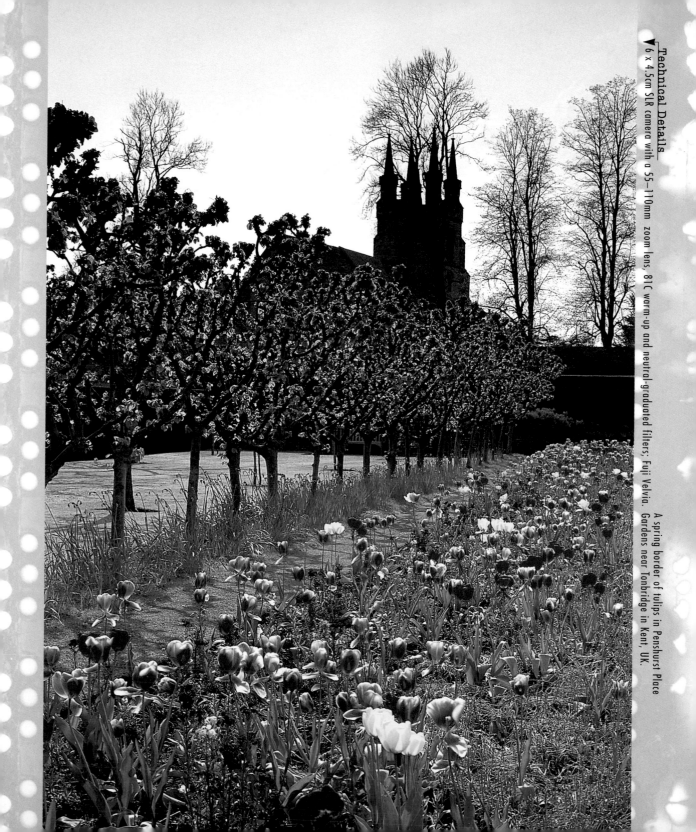

Technical Details
▼ 6 x 4.5cm SLR camera with a 55–110mm zoom lens, 81C warm-up and neutral-graduated filters; Fuji Velvia.

A spring border of tulips in Penshurst Place Gardens near Tonbridge in Kent, UK.

Emphasising Texture

The medium of photography is especially effective at conveying an impression of texture, a quality which can be particularly powerful in subjects like gardens and flowers. Texture is the form within an object's surface. It needs the subtleties of an image's tonal range to reveal it effectively and is largely dependent upon the direction and quality of the light.

Seeing

I saw this gnarled tree as I walked along the edge of a wood late on an autumn afternoon. The low-angled sunlight was glancing along its surface, revealing a very tactile texture, while the warm glow of the late sun enhanced the rich colour of the bark.

Thinking

I wanted to keep the image as simple and direct as possible and decided to frame the shot tightly, excluding details of the woodland behind and allowing only the brown bark and black background to be included in the frame.

Acting

I chose a viewpoint which created the most striking lighting effect and which also placed a featureless area of shaded background behind the tree. Then I used my zoom lens to adjust the framing in the way I wanted.

Technical Details
▼ 6 x 4.5cm SLR camera with a 105–210mm zoom lens and an extension tube; Fuji Velvia.

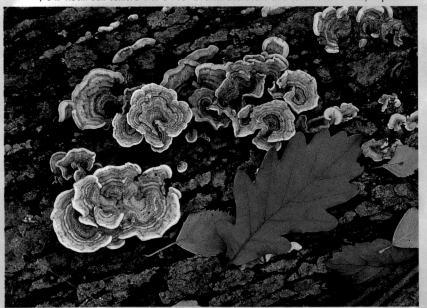

Tree fungi.

This arrangement of autumn fungi on the trunk of a fallen tree depends for its appeal upon a limited colour range and the contrasting textures of the bark, leaves and fungi. To emphasise this, I opted to frame the image very tightly using an extension tube to allow close focusing. The soft light of the shaded wood was ideal as the textures are quite subtle and strong – directional sunlight would have created excessive contrast with bright highlights and dense shadows. I used a small aperture to ensure adequate depth of field.

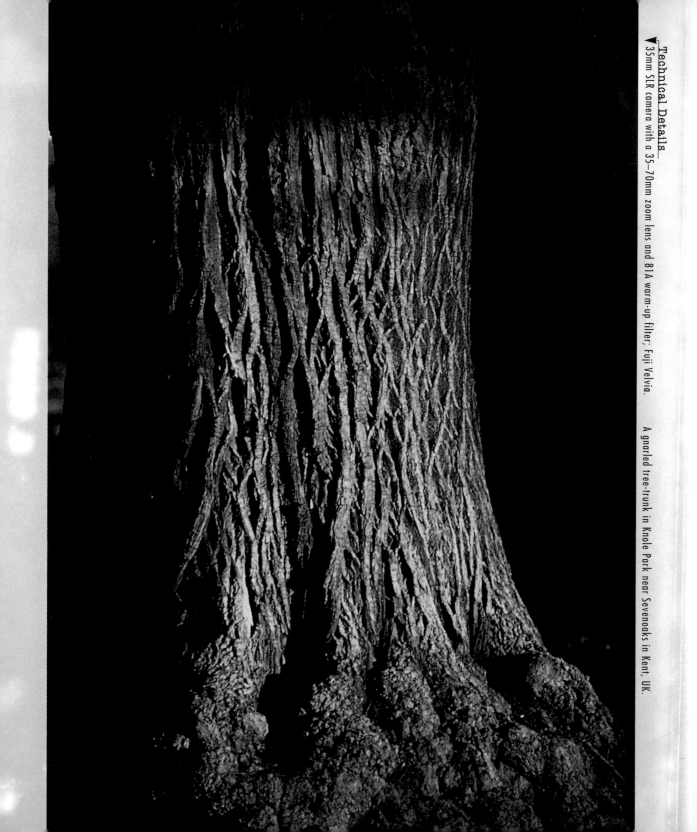

Technical Details
▼ 35mm SLR camera with a 35—70mm zoom lens and 81A warm-up filter; Fuji Velvia.

A gnarled tree-trunk in Knole Park near Sevenoaks in Kent, UK.

Emphasising Texture

Technical Details
▼ 6 x 4.5cm SLR camera with a 55–110mm zoom lens and an extension tube; Fuji Velvia. My back garden, Kent, UK.

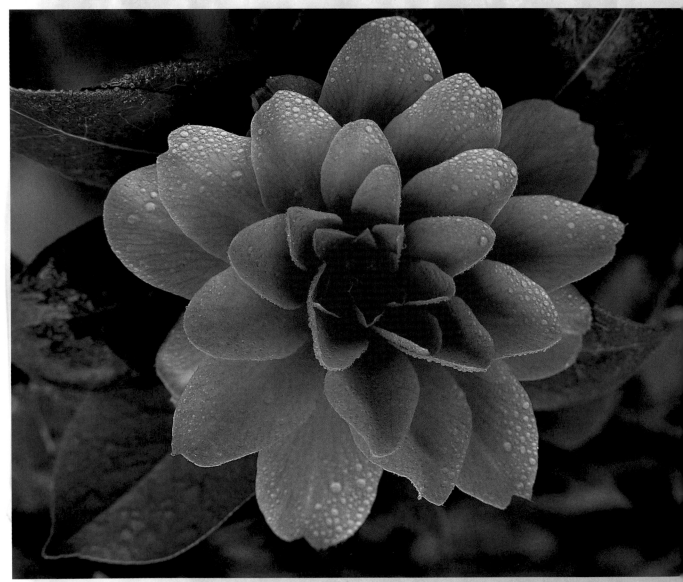

Technical Details
▼ 6 x 4.5cm SLR camera with a 105–210mm zoom lens, polarising and 81B warm-up filters; Fuji Velvia.

Great Dixter in East Sussex, UK.

This shot of a border of salvia and pelargoniums by Julien Busselle has a pronounced textural effect partly because of the way the colours of the individual flowers and leaves are distributed and partly through the way in which the light has created highlights and shadows. He used a long-focus lens to frame a small section of the border quite tightly and set a small aperture to obtain maximum depth of field. He used a polarising filter to keep the colours saturated and a warm-up filter to prevent a blue cast.

Seeing

This camellia bush is in my garden and I had been watching it bloom for some days. On this particular morning there were a number of near-perfect blooms and the shaded sunlight was creating a very pleasing effect, giving a luminous glow.

Thinking

I looked at a number of blooms with a view to taking a single, close-up image and some, although otherwise ideal, were simply in a position or angled in such a way as to make it impossible to obtain a good view of them.

Acting

This one proved to be the most suitable flower but I needed to have the camera up quite high. I also pulled the bloom down a little with some thread and moved a couple of unwanted details from the background in the same way. The water droplets were a cheat, added with the aid of a fine plant spray. I felt this enhanced the textural and tactile quality of the image and was not unnatural, as earlier in the morning there had been some dew on the blooms.

Framing the Image

There is a widely-quoted rule of composition that the image should be framed so that the main point of interest is placed where lines dividing the image into thirds intersect. While this will, in most cases, produce a pleasing effect, it should not be followed slavishly — it is important to consider the overall balance of the image before deciding on the way it is framed.

Seeing

This attractive old timbered farmhouse would make an appealing picture at the best of times but when I passed it on this occasion the sunlight was falling on it at a perfect angle and the sky behind was a beautifully clear blue.

Thinking

I felt that the pathway lined with roses and lilies leading towards the door would provide an ideal foreground and help to create a sense of depth in the image. I also felt that the image might well provide a suitable cover for the brochure I was illustrating.

Technical Details

▼ 6 x 4.5cm SLR camera with a 105–210mm zoom lens and 81C warm-up filter; Fuji Velvia.

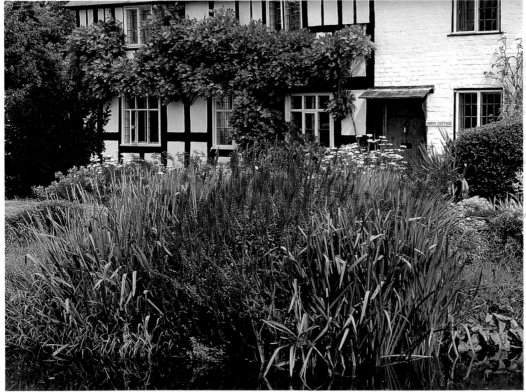

A cottage in the village of Eardisland in Hereford and Worcester, UK.

I framed this image quite tightly using a long-focus lens because I wanted to maximise the effect of the colourful display of salvia on the river bank in front of the cottage and the attractive timbered façade. Also the sky was rather pale and milky and would have detracted from the image.

Notice how much more effective the image is when composed in an upright format than as a horizontal (landscape).

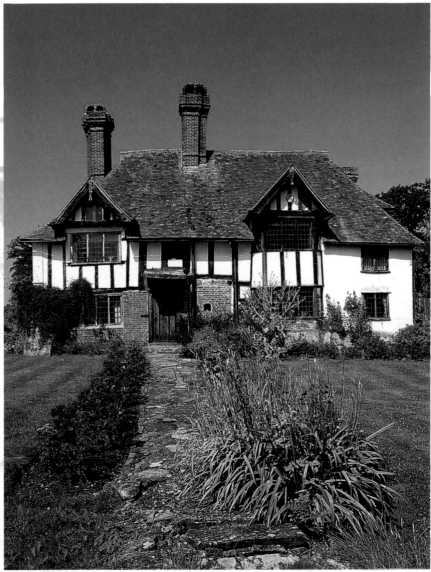

Acting

I chose a viewpoint from where the path led **directly away** from the camera and turned the camera to an **upright format**, framing the image to include as much of the foreground as possible, as well as a good area of the **blue sky** which might be used for a **headline**. I used a **polarising filter** to increase the colour saturation of the blue sky and an 81C warm-up filter to counteract the potential **blue cast** created in midday summer sunlight and with a deep blue sky.

Rule of Thumb

By far the majority of photographs taken with 35mm cameras are in landscape format. This is often simply because it is easier and more comfortable to hold the camera in this way, although quite often an upright shape would provide a more pleasing composition. It can help to make a habit of always looking first at a potential picture with the camera held upright to be sure of not overlooking this possibility.

A farmhouse near the village of Pluckley in Kent, UK.

Technical Details
6 x 4.5cm SLR camera with a 50mm wide-angle lens, polarising and 81C warm-up filters; Fuji Velvia.

Framing the Image

Seeing

This charming small semi-tropical garden looked very appealing from a variety of angles but the raised viewpoint from the villa's small terrace provided a rather different view from those seen at ground level.

Thinking

I wanted to convey something of the intimate and peaceful atmosphere of the garden and decided to use the wicker chair and part of the balcony as a frame within a frame for this shot to give the image an enclosed feeling.

Acting

The space was quite restricted and I needed to use the widest setting on my zoom lens and to move the camera as far away from the chair as I could, raising it high enough to see over it to the pool and garden beyond. I set a small aperture to obtain maximum depth of field and used a polarising filter to increase the colour saturation of the image.

Technical Details
▼ 6 x 4.5cm SLR camera with a 55–110mm zoom lens; Fuji Velvia.

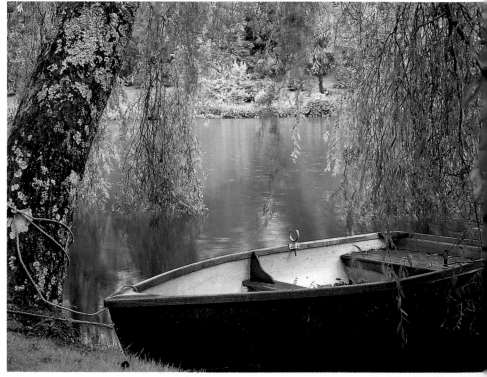

Marwood Hill near Barnstaple in North Devon, UK.

Julien Busselle used the tree trunk, overhanging willow branches and the boat as a frame for this picture in a similar way to the image on the facing page. The limited colour range, with only the boat and distant clump of yellow flowers providing a contrast with the green foliage and reflections, has helped to emphasise the peaceful atmosphere of this scene.

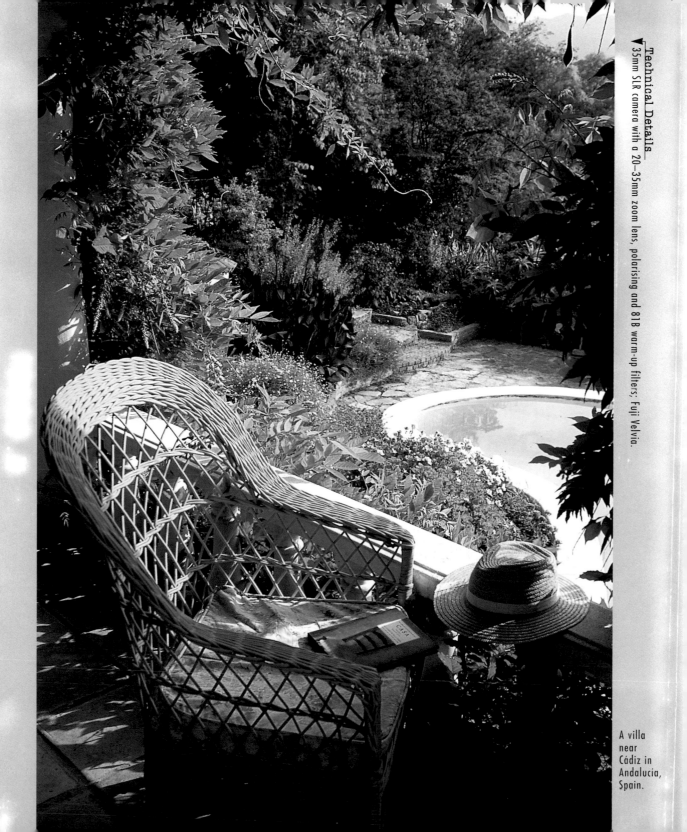

Technical Details
35mm SLR camera with a 20–35mm zoom lens, polarising and 81B warm-up filters; Fuji Velvia.

A villa
near
Cádiz in
Andalucia,
Spain.

Technical Details

▼ 35mm SLR camera with a 20–35mm zoom lens, polarising and 81C warm-up filters; Fuji Velvia.

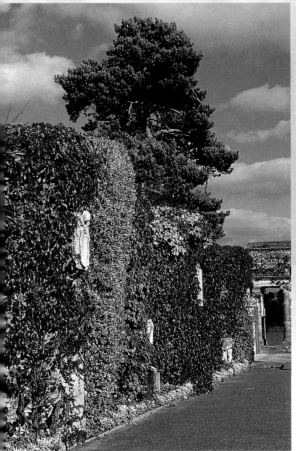

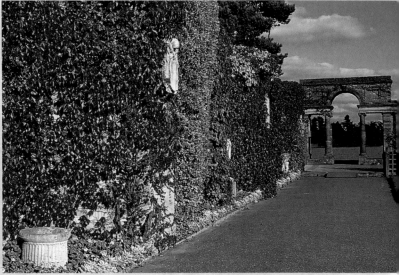

Hever Castle Gardens near Edenbridge in Kent, UK.

These two photographs, taken from the same viewpoint, demonstrate how strikingly the composition of an image can be changed by the simple action of switching from a landscape to an upright format. Although the archway is lost in the upright shot, I feel it works better as the inclusion of the tree creates a more dynamic shape. I used a polarising filter to increase the colour saturation of the image.

Seeing

The distant white bench reflected in the lake became the focus of attention for Julien Busselle in this scene, while the dark green tones which dominate the image gave it an added drama.

Thinking

Julien decided to include the foreground flowers which introduced another colour and helped to lead the eye towards the bench.

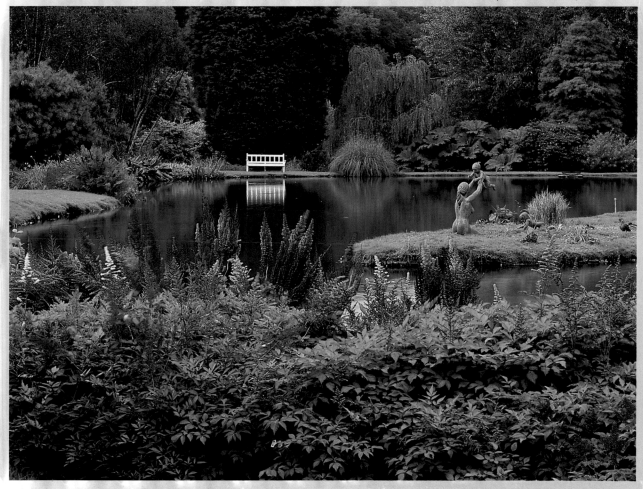

Acting

He chose a viewpoint which placed the mass of flowers in the gap created by the green lakeside bank and framed the shot using his zoom lens. Then he angled the camera so that the bench was placed just off centre on a line about one-third of the way from the top of the frame.

Rule of Thumb

When deciding how best to frame a shot it is first necessary to identify the main focus of attention in the scene. This will help you decide how much more of the scene needs to be included and where the most effective place for this key detail will be within the image.

Using Perspective

Perspective is the effect created by the diminishing size of objects as they recede from the camera, as you can see looking down a tree-lined avenue, for instance. It's a valuable way of helping to give an image a sense of depth and distance and also contributes to the impression of solidity and the three-dimensional quality which a photograph can have.

The main lake in Sheffield Park Gardens near Lewes in Sussex, UK.

Seeing

It was almost impossible not to react to the deep red leaf colour of this autumnal acer, but I was also attracted to the silhouetted trees on the far shore of the lake and their reflections in the water.

Thinking

In normal circumstances I try to avoid featureless, pale skies in colour landscape photographs like this but I realised that a combination of the deep red foliage, the white sky and black silhouetted trees could be quite powerful.

Acting

I decided to use a wide-angle lens which would enable me to get very close to the tree and fill the frame with the colour of its leaves but, at the same time, allow me to include a large area of the sky, lake and opposite bank. This, in turn, has given the image of strong sense of depth and distance. I felt that the exposure might be a problem as the large area of bright sky could result in underexposure, so I bracketed quite widely to be safe. In the event, I preferred a slightly underexposed frame to that which was indicated.

Rule of Thumb

The effect of perspective varies according to the relative distances between the camera, the nearest objects and those furthest away. If the image includes both foreground and distant objects the perspective effect will be marked, so that, for instance, a group of flowers nearby can appear much larger than a distant tree. But if there is no immediate foreground and all the principal objects are some distance away from the camera there will be a minimal suggestion of perspective and objects will be shown close to their true relative size.

Technical Details
▼ 6 x 4.5cm SLR camera with a 50mm lens and 81C warm-up filter; Fuji Velvia.

Using Perspective

Seeing

The dense planting of lavender and nicotiana in this scene created a very striking mixture of colour and texture, and I spent a while looking for a viewpoint which would combine these details in the most telling way.

Thinking

I felt that the most effective way of exploiting the qualities of colour and texture would be to use the perspective effect to compress the details of the scene. I was also aware that the image needed an additional, contrasting detail to give the composition a positive focus of attention.

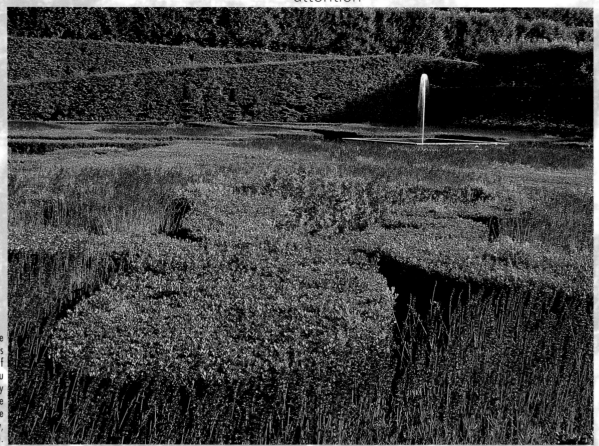

The Gardens of Chateau Villandry in the Loire Valley, France.

Powerscourt Gardens near Wicklow in County Wicklow, Eire.

This moss-covered stone seat provided a good counterpoint to the mass of flowers and green foliage behind it and added an essential element of contrast and interest to the shot, as well as helping to create a more three-dimensional quality in the photograph. I framed the shot so that the light tone of the seat and the splash of purple blooms were in opposite corners of the image and used a small aperture to ensure that both the seat and distant flowers were in sharp focus.

Acting

This viewpoint allowed me to include the fountain as the key element and also, happily, created the most pleasing lighting quality, shooting towards the late afternoon sun. I used the longest setting on my zoom lens to isolate a fairly small area of the scene, cropping out the sky, and used the smallest aperture to obtain maximum depth of field. I needed to use my lens shield device to prevent flare.

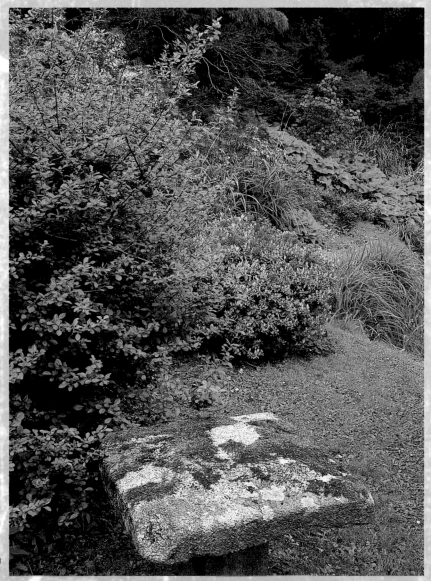

Technical Details ▶
6 x 4.5cm SLR camera with a 55–110mm zoom lens and 81C warm-up filter; Fuji Velvia.

◀ Technical Details
6 x 4.5cm SLR camera with a 105–210mm zoom lens and 81C warm-up filter; Fuji Velvia.

Colour & Design

Most photographers react enthusiastically to colourful subjects, and gardens provide an abundant source. Paradoxically, very colourful subjects can be the most difficult to photograph successfully unless a restrained approach is adopted. As a general rule, it is best to limit the dominant colours in an image to just two or three. Often pictures which are almost monochromatic are the most striking in colour photography.

Seeing

The vivid autumnal colour of the boston ivy above the blue stable doors was hard to overlook as a potential picture, and my first instinct was to shoot a fairly close-up image of these two details.

Thinking

The two colours were so strong that I decided to use them smaller in the image as a focus of attention rather than as the main feature of the image.

Acting

I found a more distant viewpoint which allowed me to include the tree in the foreground when I fitted my wide-angle lens and, although it introduced another colour, the striking contrast between its green foliage and the two smaller splashes of vivid colour seemed to enhance them all.

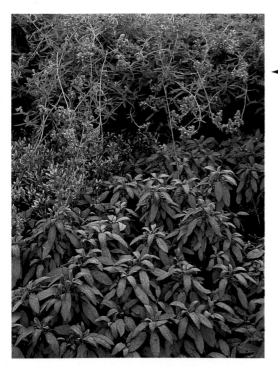

Technical Details ►
6 x 4.5cm SLR camera with a 55–110mm zoom lens and 81C warm-up filter; Fuji Velvia.

◄ Technical Details
6 x 4.5cm SLR camera with a 55–110mm zoom lens; Fuji Velvia.

The very limited colour range of this clump of sage appealed to me, together with the texture and pattern created by the leaves. I decided to frame the shot quite tightly to exclude any other details. The picture was taken in the open shade on a late sunny afternoon with a blue sky, and in normal circumstances I would have used a warm-up filter to counteract the potential blue cast. However, I felt the colour cast might enhance the monochromatic effect I wanted and shot the picture without a filter.

Rule of Thumb

One of the most effective ways of producing striking colour photographs is to look for boldly-coloured subjects which can be placed against a background with a contrasting hue, such as a yellow rose against a blue sky.

The Chateau of Georges Sand in the village of Nohant in Berry, France.

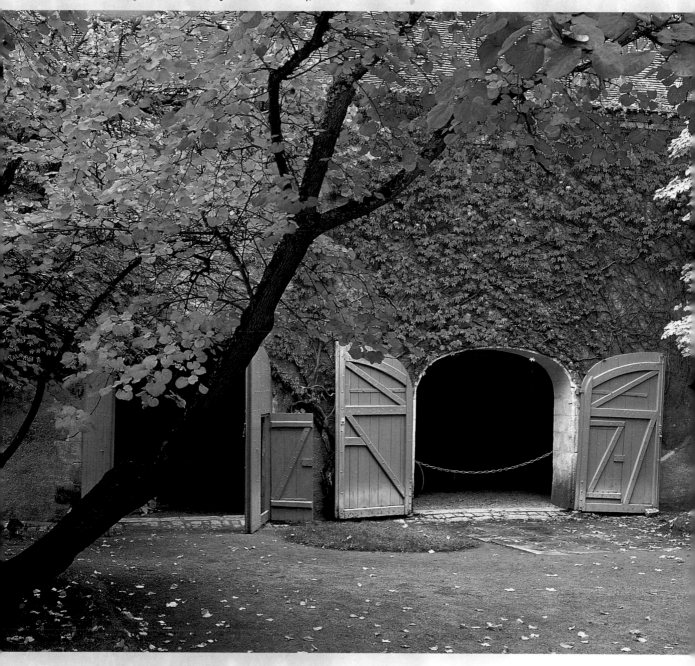

Rule of Thumb

Very colourful subjects are often much more effective when photographed in soft, diffused daylight such as on a hazy or overcast day or in open shade on a sunny day. Direct sunlight can create too many bright highlights and shadows which dilute the effect of bold colours, creating far less impact.

Seeing

This border of scarlet tulips presented one of those situations where it is easy to lose the striking effect of the colour because of the presence of too many others.

Thinking

I felt that my best option was to shoot a close-up image of just a few blooms. But there was a danger that the brick-wall background might still be too distracting.

Acting

I decided to use a fairly distant viewpoint and frame my image tightly with a long-focus lens, selecting just two blooms. I used a wide aperture to limit the depth of field which has resulted in the brick wall being very soft and unobtrusive and provided a sympathetic foil for the red tulips.

Technical Details

▼ 35mm SLR camera with an 80–200mm zoom lens and 81B warm-up filter; Fuji Velvia.

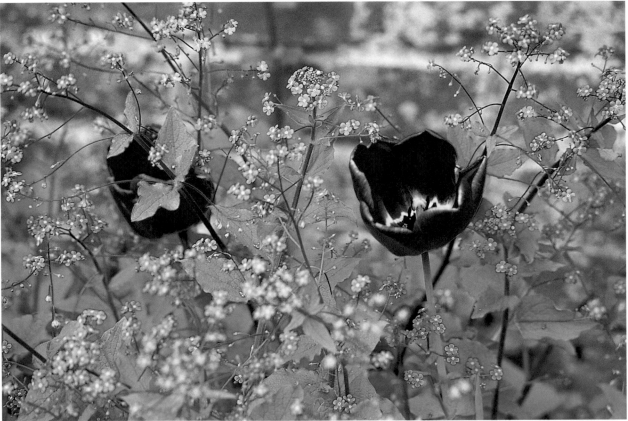

Garden in Kent, UK.

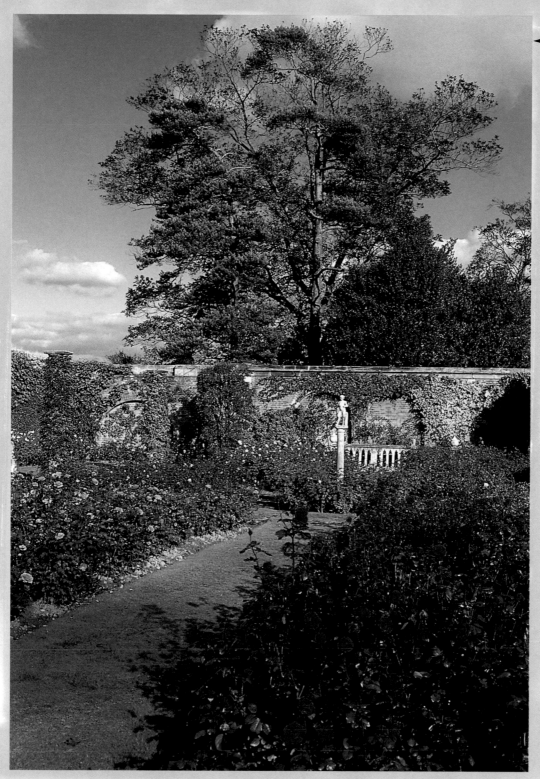

Technical Details

35mm SLR camera with a 20–35mm zoom lens, polarising and 81C warm-up filters; Fuji Velvia.

The rose garden at Hever Castle near Edenbridge in Kent, UK.

Scenes like this can easily not work well as a colour photograph because there are too many conflicting colours. In this case the very bright colour of the roses in the foreground has been subdued because they are partially shaded. If they had been in full sunlight I feel the image would not have been so pleasing. I used a polarising filter to increase the density of the blue sky and the colour saturation of the blooms.

Close-up Photography

Moving much closer to plants and flowers can often
reveal details of astonishing beauty. Close-up photography can highlight shapes
and patterns in natural forms which wouldn't otherwise be visible and give them an
importance and impact far beyond their scale.

Seeing

I'd noticed this ivy-covered stone wall from some
distance away and had, in fact, shot some pictures
from a distance of about two metres. The
colour of the stone and green leaves made
an effective composition along with the contrasting
textures.

Thinking

I'd also noticed the small patches of lichen but
they were rather lost in the larger-scale view I'd
taken, so I moved in much closer to take a better
look. I realised that there was, perhaps, a
more striking picture to be had by
isolating a very small area of the wall.

Acting

The leaves in this shot, taken from only 30cm
or so away, are very small. By closing in like
this, I was able to find a spot where the
leaves were similar in size to the patches of
lichen and managed to combine them in a
way which created a nicely balanced
composition. I used a small aperture to
ensure adequate depth of field.

Technical Details ▶
35mm SLR camera with a 90mm macro lens and 81A
warm-up filter; Fuji Velvia.

Stone wall near Matlock in Derbyshire, UK.

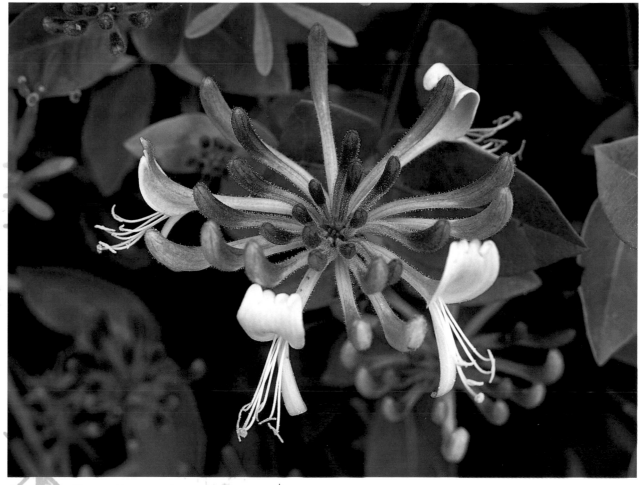

Close-up shot of honeysuckle.

This honeysuckle bloom was photographed in a Devon hedgerow on a very dull, overcast day when the soft lighting was ideal to record the subtle texture and colours. I used a small aperture to obtain sufficient depth of field.

▲ Technical Details

6 x 4.5cm SLR camera with a 55–110mm zoom lens and an extension tube; Fuji Velvia.

Technique

Most cameras have lenses which will only focus down to a couple of metres or so, but for close-up photography it's often necessary to come in much closer. Extension tubes or a bellows unit can be fitted between an SLR camera body and a normal lens to accomplish this, but a macro lens can be a good investment for those interested in producing this type of image as it can create a life-size image of a subject on the film.

Close-up Photography

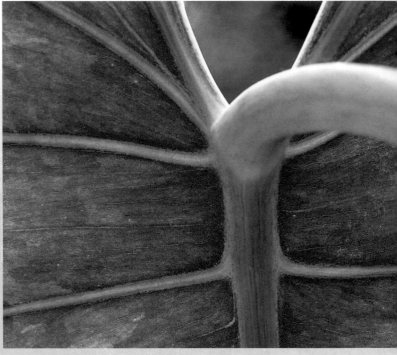

Gardens of Chateau Le Roche Courbon near Saintes, in the Charante region of France.

The strong side lighting has created a strong sense of shape and texture in this shot of a yucca plant by Pat Busselle. The dark-toned background has helped to throw the blooms into strong relief and created an image with considerable impact.

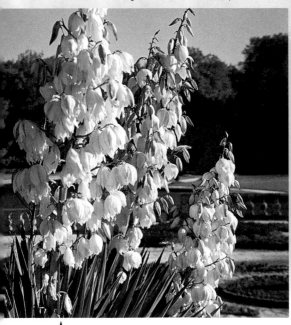

Extreme close-up shot of a rubber plant.

This shot of a dying rubber plant leaf was taken from a distance of only about 30cm using a macro lens. The viewpoint and framing were chosen to create an almost abstract quality in which the stem and the back-lit veins of the leaf have created dominant lines.

▲ Technical Details
35mm SLR camera with a 28–35 zoom lens and Fuji Super G 200.

Technical Details ►
35mm SLR camera with a 35–70 zoom lens and an extension tube; Fuji Velvia.

Close-up shot of a palm leaf.

Isolating a small section of this palm leaf and framing it so
that the veins create diagonal lines has produced an image
with a strong graphic quality which the lack of other colours
has emphasised.

Technique

When photographing close-ups of plants and flowers in
situ using small apertures, it's often necessary to use
slow shutter speeds. This can be a problem when there
is even slight wind movement. A useful technique is to
erect a small protective screen on the windward side of
the subject.

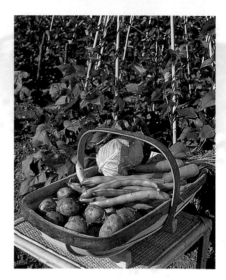

The Subject

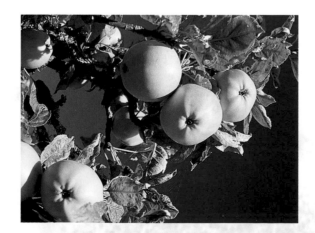

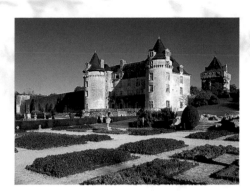

2

A formal garden would be photographed
very differently to a woodland or cottage
garden. This chapter demonstrates the techniques you can use to reveal the
appealing qualities of the most frequently encountered garden subjects.

Borders & Shrubs

The planting of borders and the distribution of flowering shrubs are what give a garden its basic structure and colour. Garden design is a skilled art and it's often only a question of careful choice of viewpoint and framing to ensure satisfying pictures with a good sense of design and colour.

Seeing

The circular borders planted with pansies around the fruit trees were a striking feature of this lawned area. Finding a suitable viewpoint was difficult as they were widely spaced and my initial attempts resulted in too much lawn and not enough colour.

Thinking

I decided to select just one island border and use a distant viewpoint and long-focus lens to compress the colour and shapes it contained.

Acting

This viewpoint allowed me to place the distant garden wall behind the tree which, together with the small area of grass, helped to contain the image and provide an uncluttered background. I framed the image very tightly, partly to concentrate attention on the contrasting colours of the flowers but also to crop out the blank sky above the wall. It was a very dull, overcast day which provided an ideal light for the colour subject, but the inclusion of white sky would have destroyed the image's impact.

Powerscourt Gardens near Wicklow in County Wicklow, Eire.

Rule of Thumb

It's best to resist the temptation to shoot your pictures right away as the viewpoint you first see is not always the best and it pays to explore all the possibilities first.

See how much less effective a wider view of the scene would have been and how distracting the top of the wall and blank sky would have looked.

Technical Details
▼ 6 x 4.5cm SLR camera with a 105–210mm zoom lens and 81B warm-up filter; Fuji Velvia.

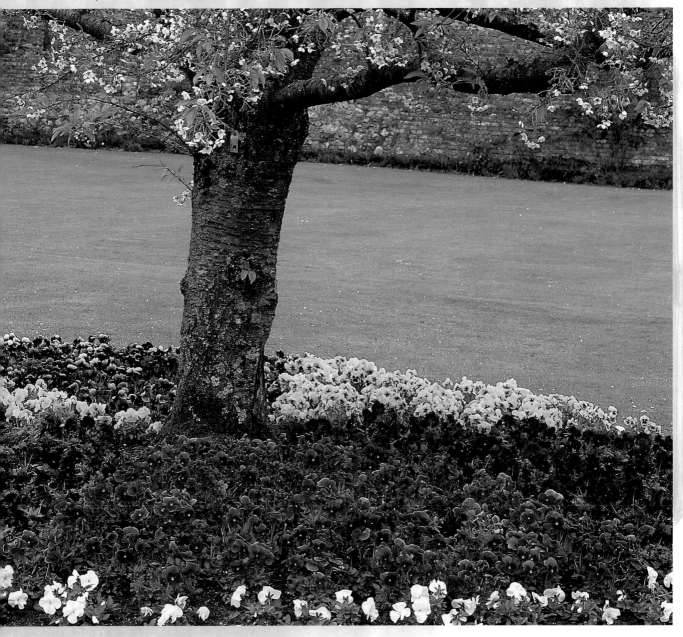

Borders & Shrubs

Technical Details
▼ 6 x 4.5cm SLR camera with a 105–210mm zoom lens, polarising and 81B warm-up filters; Fuji Velvia.

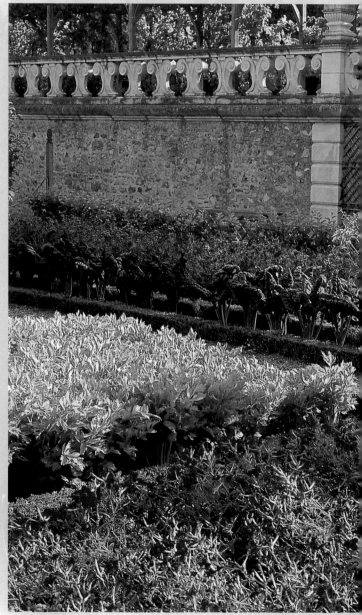

Seeing

A striking feature of these gardens is the unusual creative planting which combines flowers with vegetables. This section of the garden caught my eye because the red blooms of the nicotiana and scarlet stems of the chard created an eye-catching zigzag.

Thinking

I chose a viewpoint from where this effect was most noticeable and which placed the ornamental wall at the top of the image.

Acting

I used a long-focus lens to isolate a small section of the scene, emphasising the zigzag, and to crop out distracting details above the wall. I used a polarising filter to enhance the colour saturation and a warm-up filter to give the reds an added boost. I selected a small aperture to ensure the image was sharp from foreground to background.

Rule of Thumb

It's very tempting when you see colourful borders or arrangements of shrubs to photograph them as they appear to the eye. But this can produce very disappointing results as we see things in a very selective way, focusing our attention only upon what interests us in a scene and ignoring other details. When taking photographs it's necessary to impose this selectivity in the way you frame and compose your shots if you are to avoid muddled and uncohesive images.

The gardens of Chateau Villandry near Tours in the Loire Valley, France.

Technical Details
▼ 35mm SLR camera with a 20–35mm zoom lens, polarising and 81B warm-up filters; Fuji Velvia.

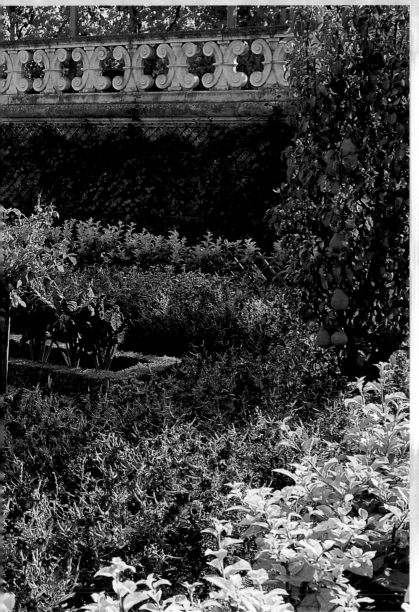

A villa near Estepona in Andalucía, Spain.

The vivid colour of this bougainvillea in full bloom needed a fairly neutral contrasting background, so I found a viewpoint which enabled me to place the white wall of the villa behind the vine. I used a warm-up filter because the colour quality of the midday summer sunlight was quite blue, and a polarising filter to increase the colour saturation of the blooms.

Garden Landscapes

A garden is a man-made landscape and, as such, it offers the photographer the great advantage of having been consciously constructed with composition in mind. Unlike conventional landscapes, where the beauty of the countryside can be marred by man-made intrusions, a garden can be beautiful because of them.

Seeing

The first colours of the autumn foliage were beginning to appear on this visit to the garden and the effect of this red-leafed tree was quite dramatic in contrast to the still-green trees around it. The light was also sparklingly clear, which gave the scene a wonderful clarity.

Thinking

I wanted to use the tree as a focus of attention in a wider view of the garden and chose this viewpoint close to the edge of a small lake where it would create some interest in the foreground. The sky, too, was very attractive – a good, clear blue with dense white clouds.

Acting

I framed my shot and tilted the camera upwards so that most of the large white cloud which had appeared was included and the tree was placed on a line about one-third from the bottom of the frame. I used the widest setting on my zoom lens to accommodate a little of the water and the reflections in the foreground and angled the camera so the tree was slightly off-centre. I used a polarising filter to make the sky a richer blue and give the cloud greater relief, and a warm-up filter to emphasise the rich colour of the foliage.

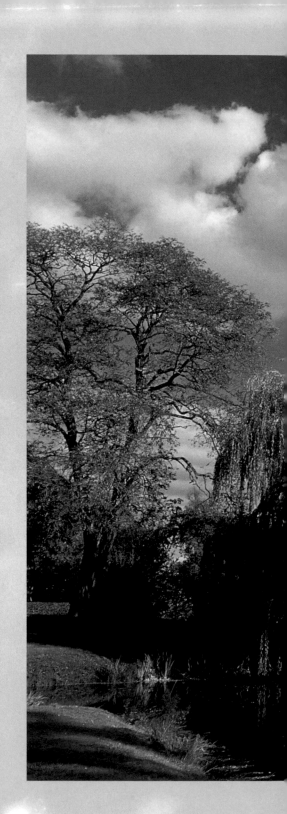

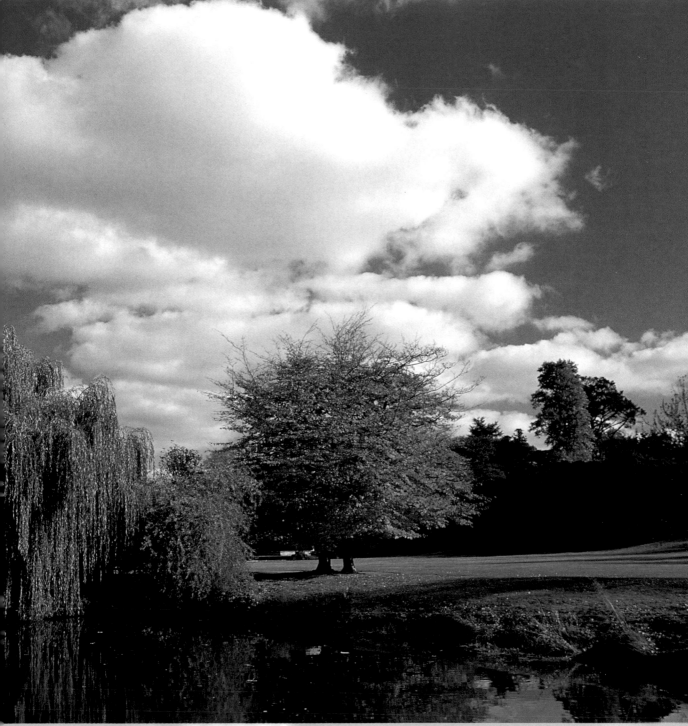

Technical Details
▼ 35mm SLR camera with a 20—35mm zoom lens, polarising and 81C warm-up filters; Fuji Velvia.

The gardens of Hever Castle near Edenbridge in Kent, UK.

Garden Landscapes

__Technical Details__
▼6 x 4.5cm SLR camera with a 55–110mm zoom lens,
polarising and 81B warm-up filters; Fuji Velvia.

Mount Ushmore Gardens near Wicklow in County Wicklow, Eire.

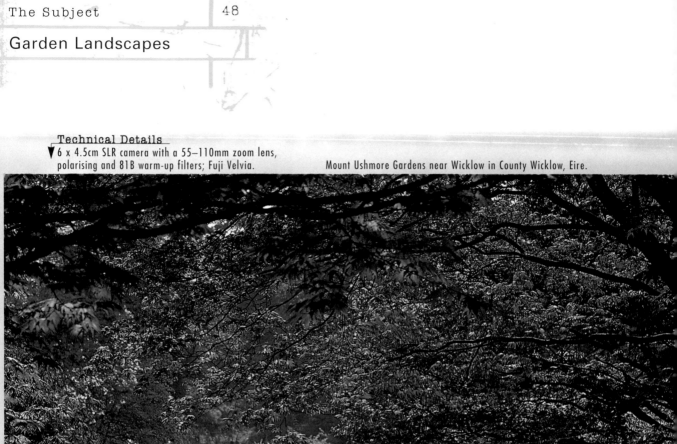

Seeing

It was the rich colour of the acer foliage which attracted me to this scene, contrasted against the soft spring green of the grass beyond.

Thinking

The effect of the leaf colour was strongest when viewed against the light so I looked for a viewpoint which would enable me to capture this and where I would also be close enough to the tree to make it the dominant colour. I also wanted to find a way of excluding the rather pale, milky sky which would have diluted the effect of the rich colours.

Acting

This viewpoint achieved my aims but I needed to use a wide-angle lens to include as much of the tree as possible. I found that a polarising filter had a dramatic effect on the red leaves, making them much richer, and I used an 81B warm-up filter to emphasise the reds and greens even more.

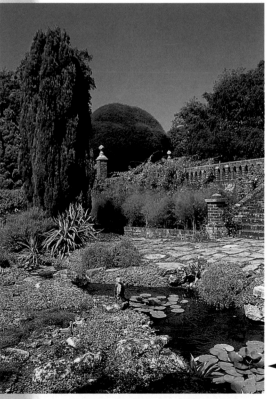

Doddington Manor Gardens near Ashford, in Kent, UK.

I used the camera in upright format with a wide-angle lens for this shot as I wanted to include both the pond in the foreground and the tall tree in the background. I used a polarising filter to make the sky a deeper blue and increase the colour saturation of the foliage and an 81EF warm-up filter as the blue sky and midday summer sunlight would have otherwise created a blue cast.

Technical Details

35mm SLR camera with a 20–35mm zoom lens, polarising and 81EF warm-up filters; Fuji Velvia.

Gardens & Architecture

Gardens are usually designed to complement a house, and even when they are quite separate they often have architectural features which are incorporated into their design. Including buildings in garden photographs can frequently provide an interesting element of both contrast and scale.

Seeing

This was a day of beautiful summer sunlight which was illuminating the front of the house perfectly. But it was also quite harsh and contrasty and created an unpleasant effect on the roses and lavender in front of it.

Fitz House in the village of Teffont Evias in Wiltshire, UK.

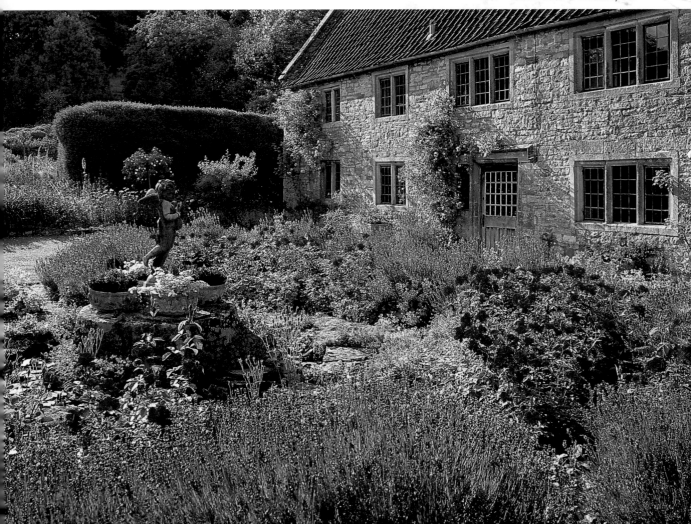

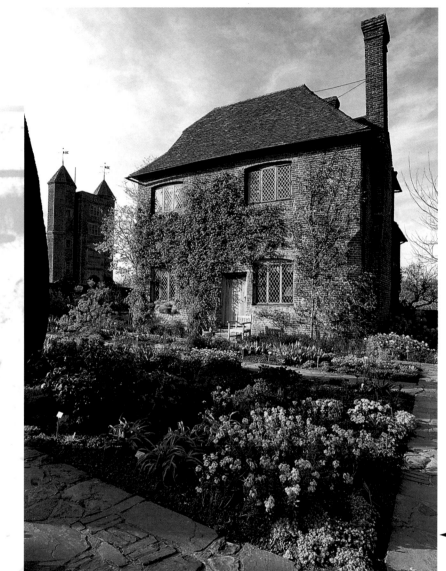

Rule of Thumb

If you do need to tilt the camera upwards to include the top of a building, it's best to do it in a very positive way and to accentuate the converging verticals, using this as an element of the composition.

Sissinghurst Castle Gardens near Tenterden in Kent, UK.

I used a wide-angle shift lens to photograph this cottage as the viewpoint was quite restricted and I wanted to include both the flower border in the foreground and the top of the tall chimney without having to tilt the camera, which would cause the vertical lines to converge. The foreground shadow has subdued the colour of the flowers quite effectively, preventing them from being too distracting and allowing the building to be the main focus of attention.

Technical Details
6 x 4.5cm SLR camera with a 50mm shift lens, polarising and 81C warm-up filters; Fuji Velvia.

Thinking

I thought that shooting towards the light might create a more pleasing effect and walked around the garden looking for a viewpoint which would improve the lighting quality and also provide an interesting foreground.

Acting

This viewpoint seemed to fulfil both needs and from here the lighting also created a very atmospheric quality. I decided to frame the shot so that most of the cottage roof was excluded from the image as well as part of its façade – this threw more emphasis on to the the foreground and made the most of the flower colour.

Technical Details
6 x 4.5cm SLR camera with a 55–110mm zoom lens and 81C warm-up filter; Fuji Velvia.

Technical Details

6 x 4.5cm SLR camera with a 35mm wide-angle lens, polarising and 81EF warm-up filters; Fuji Velvia.

Rule of Thumb

Taking successful photographs of buildings often means shooting at a very specific time of day – even a slight change in the direction of sunlight can make a significant difference to the quality and effect of the image.

Technical Details

6 x 4.5cm SLR camera with a 50mm shift lens and 81C warm-up filter; Fuji Velvia.

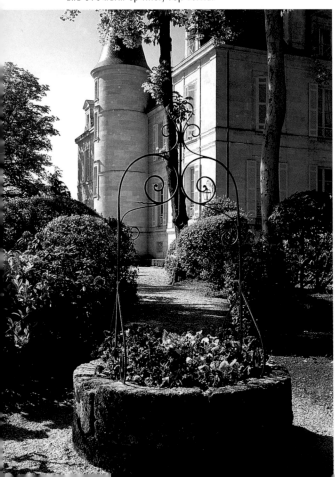

The garden of Chateau Pichon Longueville, Comtesse de Lalande in the Medoc region of France.

I'd arrived at this chateau in the very early morning to photograph its façade but could not resist stopping for a moment to shoot this ancient well, as first light was the only time this part of the garden was illuminated. I used a shift lens to eliminate some of the foreground but was unable to include all of the chateau's tower without moving further back. This would have made the well too small and I felt that by including the top of the tower I would also have too much sky in the picture.

Seeing

The sharp, clear light of this late autumn day created a very crisp, bright scene which was bordering on being too contrasty, especially on the chateau itself, where the central part of the façade was in quite deep shadow. If photographing the building had been the sole purpose of my picture I would have returned at a later time when the light was more front-on.

The chateau of La Roche Courbon near Saintes in the Charente region of France.

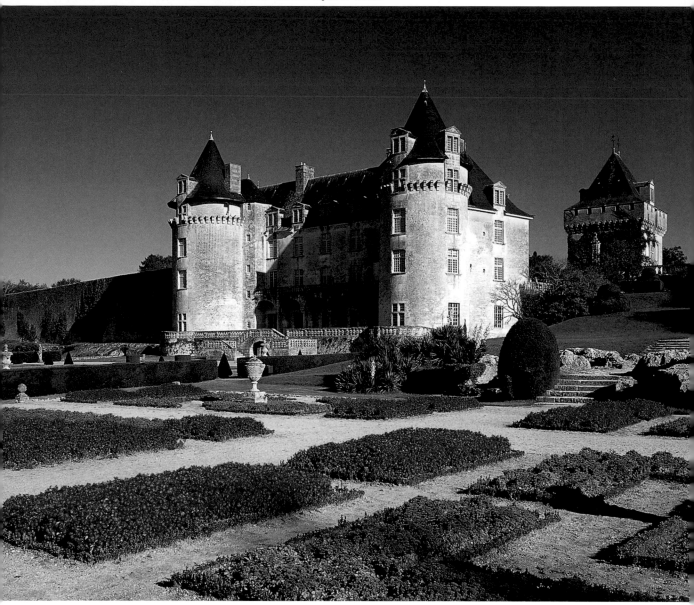

Thinking

I felt that as I wanted to show the building in the **setting** of its formal garden I could afford to take a much more **distant viewpoint** and allow the building to be quite small in the frame. I needed to take my shot quite soon as the long shadows were already beginning to **encroach** on the flower beds in the foreground.

Acting

I decided to use a very **wide-angle** lens. This allowed me to include a large area of the flower beds in the **foreground,** as well as the keep behind the chateau, and helped to make the shadow on the façade a bit less noticeable. I used a **polarising filter** to make the sky a deeper blue and an 81EF warm-up filter.

Water Features

The presence of water in a photograph invariably adds an element of interest to an image, with the opportunity to make use of its reflective nature and movement. Garden designers are equally aware of its visual potential, and many great gardens have made full use of its qualities.

Seeing

I'd visited this famous garden on a number of occasions before but had never managed to be there when the light on this lake created an interesting enough effect. On this occasion I arrived very early, waiting for the garden to open, and the light was much more atmospheric.

Thinking

Finding a suitable viewpoint depended not only on creating the best composition, with the right lighting quality, but also on avoiding the large numbers of other visitors who had also arrived very early.

Acting

This viewpoint proved to be the best compromise. By using a very wide-angle lens I was able to include some foreground interest while shooting almost directly into the light, which created a pleasing atmospheric quality. I had to wait for a brief moment before shooting as a constant stream of people was passing along the opposite bank. I also needed to use my lens shield gadget to protect the lens from flare.

The lake at Monet's garden in Giverny near Vernon in Normandy, France.

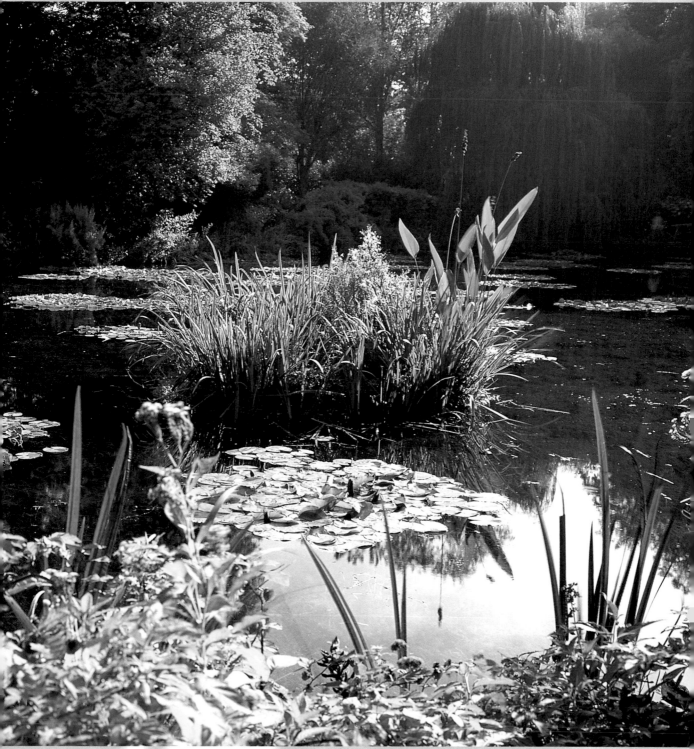

Water Features

Rule of Thumb

Photographing moving water with a slow shutter speed can create very pleasing effects, especially when it flows copiously and the shutter speed is several seconds. The effect is invariably enhanced when the water is lit softly – direct sunlight with the accompanying bright highlights tends to create a much less subtle effect.

Seeing

This popular garden is a classic example of when water is used both as a visual and an audible feature, creating a cool and peaceful ambience in a very hot place.

Thinking

I wanted to convey something of the atmosphere, but the choice of viewpoints is quite limited here and was made more so by the many visitors who thronged the relatively small space.

Technical Details

6 x 4.5cm SLR camera with a 55–110mm zoom lens and 81B warm-up filter; Fuji Velvia.

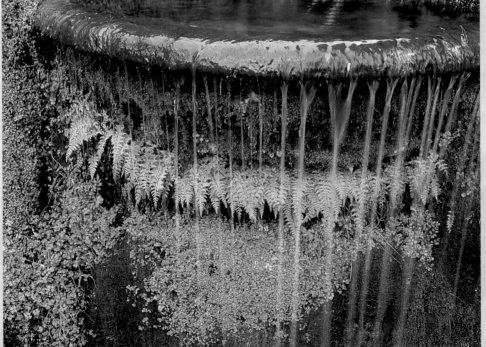

The grotto at Powerscourt Gardens near Wicklow in County Wicklow, Eire.

For this shot I decided to move in close and frame the image very tightly, restricting the colour range of the image to the green of the ferns and the neutral tones of the water and stone, which has helped to accentuate the textural quality of the image. I used a slow shutter speed of about 1/2 a second which has recorded the trickle of water quite softly.

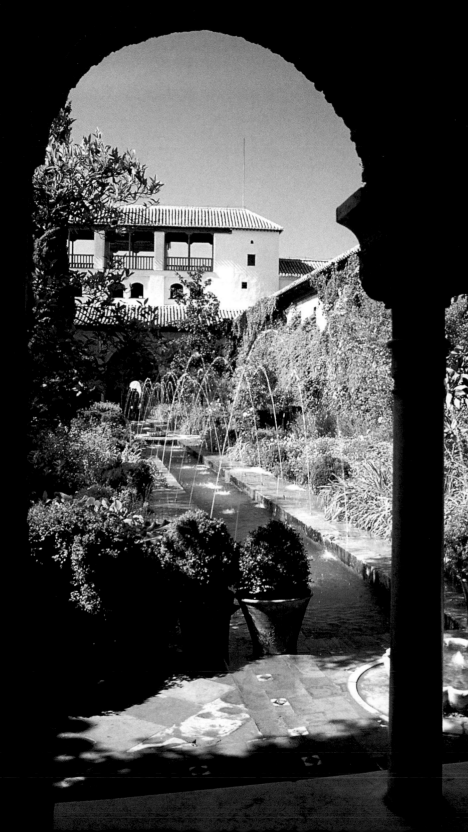

Acting

I chose a viewpoint at the **far end** of the water garden which allowed me to use the **shaded archway** as a frame to the image, creating a strong **sense of depth** and helping to enhance the peaceful and intimate nature of the place. I waited until there was a **brief gap** in the crowds before shooting.

The water garden of the Alhambra Palace in Granada, Spain.

Technical Details ➤
35mm SLR camera with a 20–35mm zoom lens, polarising and 81C warm-up filters; Fuji Velvia.

Arranged Flowers

Part of the pleasure of a garden is the ability to bring flowers indoors and use them as an element of a home's decor. This is not, of course, restricted to cut flowers. The creative use of house plants, window boxes, planted containers and so on can be seen all around us, and this aspect of plant photography can be just as satisfying as photographing in a garden.

Seeing

I saw this ancient, crumbling cottage as I drove through a small village. It would have appealed to me anyway as a picture, but the flowers made it a must.

Thinking

It was an overcast day and the lighting was soft, which suited the subject very well, but I did need to crop the image quite tightly to allow the colour of the geraniums to occupy as much of the frame as possible.

Acting

I used my zoom lens to frame the image from my roadside viewpoint so that the roof line was excluded but the small shuttered window in the top-right corner of the frame remained.

Technical Details
▼ 6 x 7cm SLR camera with a 105mm lens; Fuji Velvia.

Here you can see how the reflector was placed to throw light back into the shadows and reduce the contrast of the image.

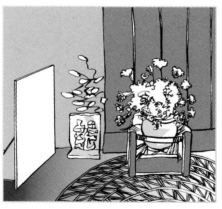

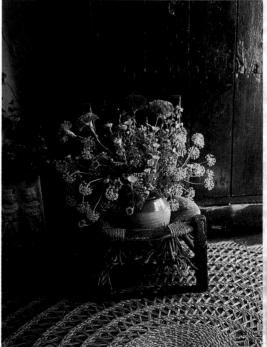

A doorway in the village of Casares in Andalucia, Spain.

This delightful arrangement of flowers was what I call a 'found still life' – it just happened to be placed there in the doorway of a small restaurant. I'd been using the village street as a location while shooting photographs of some models for a travel brochure and could not resist shooting this for myself. I had with me a large white reflector which I placed on the shaded side of the arrangement to make the shadows lighter, but otherwise it was lit by natural light from the open doorway.

Rule of Thumb

Stone buildings, walls and other features invariably look more attractive if you use a warm-up filter to enhance the colour and texture of the stone.

Technical Details

A cottage in the Dordogne region of France. ▼ 6 x 4.5cm SLR camera with a 55–110mm zoom lens and 81C warm-up filter; Fuji Velvia.

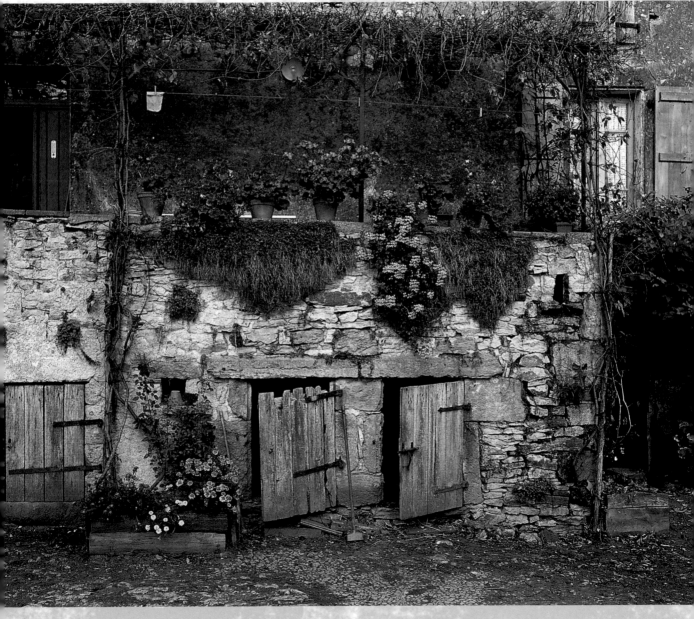

Garden Portraits

One of the most satisfying ways of photographing a garden is to treat it as a subject for a photo essay. The majority of photographs are taken with the intention of standing alone, to be viewed as single, independent images. But this can be a rather limiting way of regarding photography, and often the desire to include as much information as possible, during that single decisive moment when the exposure is made, can be a factor in producing photographs of limited visual appeal and impact. While some images are powerful enough to stand alone, hung on a gallery wall, for example, or used as a magazine cover or double-page spread, they often do not tell the viewer as much about a particular garden as a sequence of images can in the form of a photo essay.

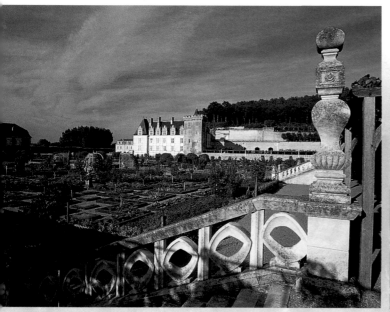

The Gardens of Chateau Villandry near Tours in the Loire Valley, France.

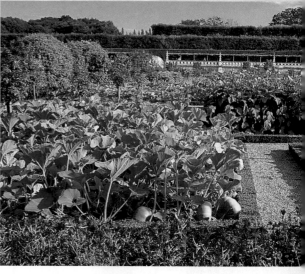

◄ Technical Details ►
6 x 4.5cm SLR camera with lenses ranging from 35mm wide-angle to 210mm long-focus with polarising and warm-up filters; Fuji Velvia.

Rule of Thumb

When shooting in sunlight, it's always advisable to plan your garden visits so that you have the opportunity to see the effect as the sun moves higher or lower in the sky. The difference between early morning, midday and evening light can be very striking and will invariably reveal picture possibilities which would not be apparent at other times.

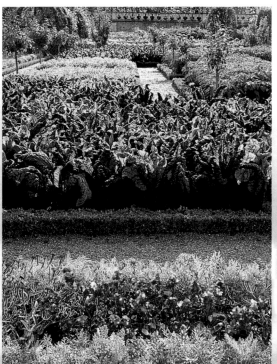

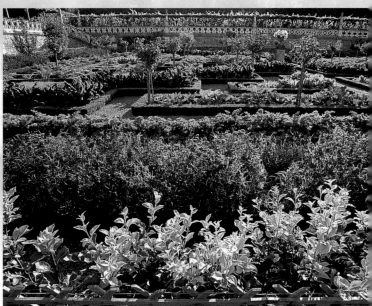

Technique

The images on the next four pages were all taken during a period of about three hours on a late-autumn afternoon with the aim of conveying an impression of the extent and variety of the design and planting of this unique garden together with its chateau. Shooting a garden portrait within a fairly limited time span helps to give the images a sense of continuity even when you have varied the viewpoints, composition, framing and lighting.

Garden Portraits

The Gardens of Chateau Villandry near Tours in the Loire Valley, France.

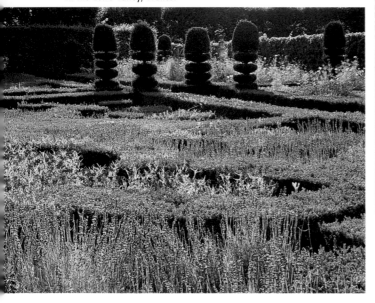

Technique

It can be helpful when shooting a garden portrait to think of your images in terms of a storyboard for a film or television production. For instance, you would have an establishing shot which showed something of the garden's layout and setting. You could then photograph the most important features, looking at ways of revealing strong visual qualities like colour, pattern and texture, followed perhaps by very close-up images of particular blooms or shrubs for which the garden is noted.

Rule of Thumb

It's always a good idea to walk around a garden several times in various directions, as it can be surprising just how differently you can see things when you approach them from a new angle and when the light is directed at them from a different position.

◄ Technical Details ►

6 x 4.5cm SLR camera with lenses ranging from 35mm wide-angle to 210mm long-focus with polarising and warm-up filters; Fuji Velvia.

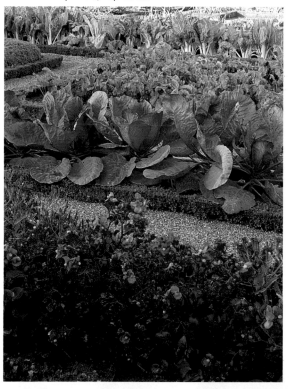

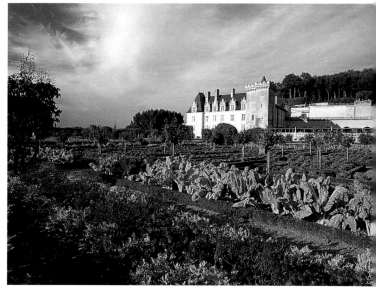

Garden Portraits

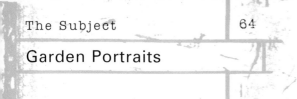

The five images on these two pages were taken during a late-summer afternoon in a much smaller and far less formal woodland garden.

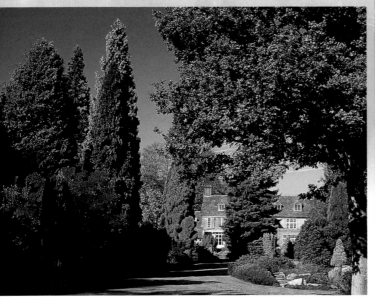

Technique

An effective way of ensuring that your pictures of a particular garden are varied enough is to make conscious changes to the way you work. If, for instance, you have been shooting with a long-focus lens, fit a wide-angle instead and, very often, a new way of seeing a place will reveal itself. In a similar way, shooting from near ground level, or from a higher viewpoint, will give a quite different perspective to a photograph taken at eye level.

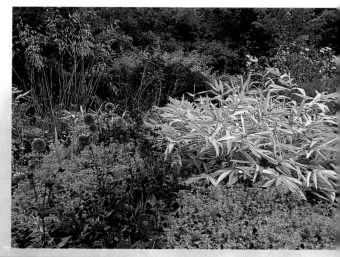

◄ Technical Details ►
6 x 4.5cm SLR camera with lenses ranging
from 20mm wide-angle to 210mm long-focus
with polarising and warm-up filters.

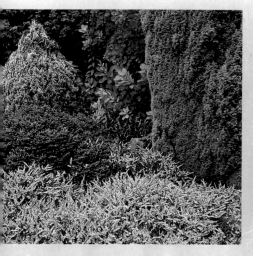

The Gardens of Great Comp near Sevenoaks
in Kent, UK.

Rule of Thumb

The main thing to consider when
compiling a portrait of a garden is how
each picture relates to the others,
making a conscious effort to alternate
wide views with close-ups of plants:
for example, a shot of a border with a
photograph of an architectural detail,
or an image where blue or green
dominates, juxtaposed to one of
primarily reds and yellows.

Trees & the Woodland Garden

Trees are, perhaps, the most magnificent of all
Nature's plants, not simply because of their scale
but also because of the intricacy of their construction and their ability to survive
over many centuries — trees have a history. The woodland environment also
creates a special form of plant life and this, too, offers the
photographer the opportunity to take garden photographs which are
rather different from the norm.

Seeing

I'd arrived very early on a late October morning to
photograph the chateau itself but was immediately
attracted by the large drifts of wild cyclamen
which carpeted the floor of the wood.

Thinking

The problem was to find a viewpoint which would
show enough of the plants to convey the density of the
flowers and would enable me to capture the
atmosphere of the wood itself in the beautiful
morning light.

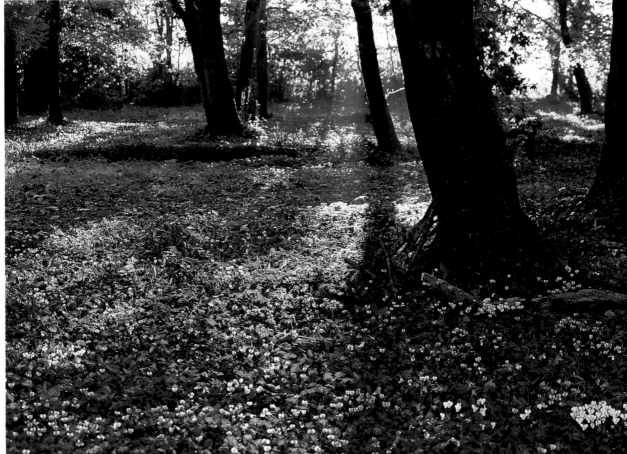

The woodland garden of Chateau Batailly in the Medoc region of France.

A square filter holder which is fitted to the camera lens and a graduated filter.

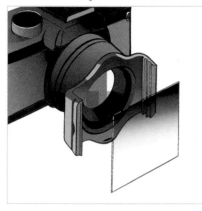

Acting

I finally settled upon this viewpoint which, with the aid of a long-focus lens, enabled me to isolate a small section of the wood where the blooms were most prolific. From here I was also able to include the shafts of sunlight filtering through the trees. This area was much brighter and needed less exposure than the foreground, so I used a neutral-graduated filter to help balance the two areas. I set a small aperture to obtain maximum depth of field.

Technique

To take a series of photographs of a specific tree at intervals through the course of a year can be a very satisfying and fascinating way of building a collection of photographs.

Technical Details ►
35mm SLR camera with a 20–35mm zoom lens, polarising and 81C warm-up filters; Fuji Velvia.

◄ Technical Details
6 x 4.5cm SLR camera with a 105–210mm zoom lens and neutral-graduated filter; Fuji Velvia.

The garden of Hever Castle near Edenbridge in Kent, UK.

I saw this elegant oak tree in the woodland garden of Hever Castle in the early summer. The foliage had not yet reached its full density and I was attracted by the dappled sunlight which had filtered through the leaves on to its trunk and branches, creating a very pleasing pattern. I framed the image quite tightly to emphasise this area and used a polarising filter to increase the colour saturation of the leaves and sky together with an 81C warm-up filter.

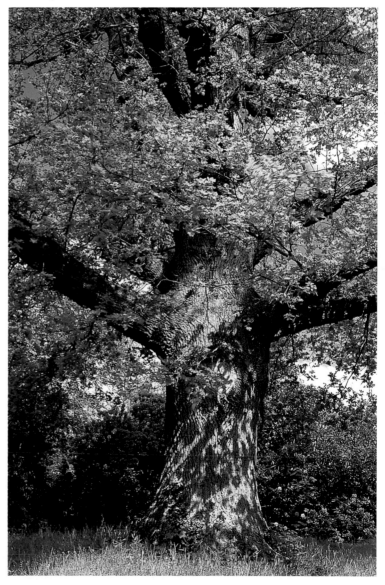

Ornaments & Details

From statues, wooden benches, archways and plant pots to fountains, walls and gazebos, ornaments are an important aspect of garden design and can contribute greatly to the interest and composition of photographs, either as the main feature of an image or in conjunction with wider views of a garden.

Seeing

This shot was taken in the winter when there was a distinct lack of colour and foliage and I was looking for other aspects of the garden to help provide interesting subjects when this rather bizarre satyr caught my eye.

Thinking

I liked the rather stark skeletons of the pollarded trees. I found the lighting on them particularly pleasing, and I decided that it could be effective to combine them with the satyr in some way.

Acting

I found a viewpoint which enabled me to place the statue between two of the trees, as well as allowing me to include part of the topiary, while the more distant chateau's outbuilding provided an additional element of interest to the composition. I used my zoom lens on a longish setting to frame the image quite tightly with 81C warm-up and polarising filters to increase the density of the blue sky.

Technical Details
▼ 6 x 4.5cm SLR camera with a 105–210mm zoom lens, polarising and 81C warm-up filters; Fuji Velvia.

The garden of Chateau Mouton Rothschild in the Medoc region of France.

The gardens of Hever Castle near Edenbridge in Kent, UK.

I included the stone bench and plaque in this shot of an autumnal boston ivy as these neutral tones accentuated the vivid colour of the foliage. I chose a frontal viewpoint in order to eliminate the impression of perspective and give the image a more graphic quality.

Technical Details
▼ 35mm SLR camera with a 35–70mm zoom lens and 81B warm-up filter; Fuji Velvia.

Ornaments & Details

Seeing

This scarecrow, attending a scarecrow festival, adds a real touch of humour to this garden and provided Julien Busselle with a great subject for this picture.

Thinking

Julien felt that the phoney crow needed to be emphasised as it could have easily become a little lost in the composition and he also wanted to carry the smile, which the scarecrow invariably provokes, over to his picture.

Acting

Choosing a low viewpoint has enabled most of the scarecrow to be silhouetted against the sky which has emphasised its raggedy shape and at the same time given the crow considerable prominence. Julien framed the shot so that the crow was placed on the spot where lines dividing the image into thirds would meet – the strongest place in the frame – and then tilted the camera sideways slightly to give the scarecrow a rather jaunty air.

Technical Details
▼ 35mm SLR camera with a 35–70mm zoom lens; Fuji Velvia.

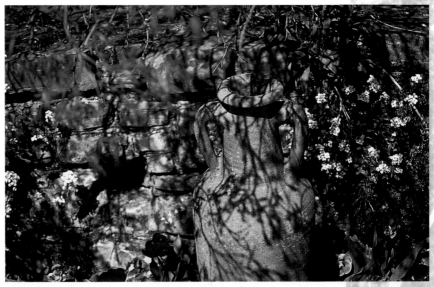

In this picture by Julien Busselle, the sunlight has created a very pleasing pattern on the ceramic urn, without which it would have been rather bland. Julien chose a viewpoint which created a degree of perspective on the wall behind using a widish aperture so that the background details were slightly unsharp, thereby giving more emphasis to the urn.

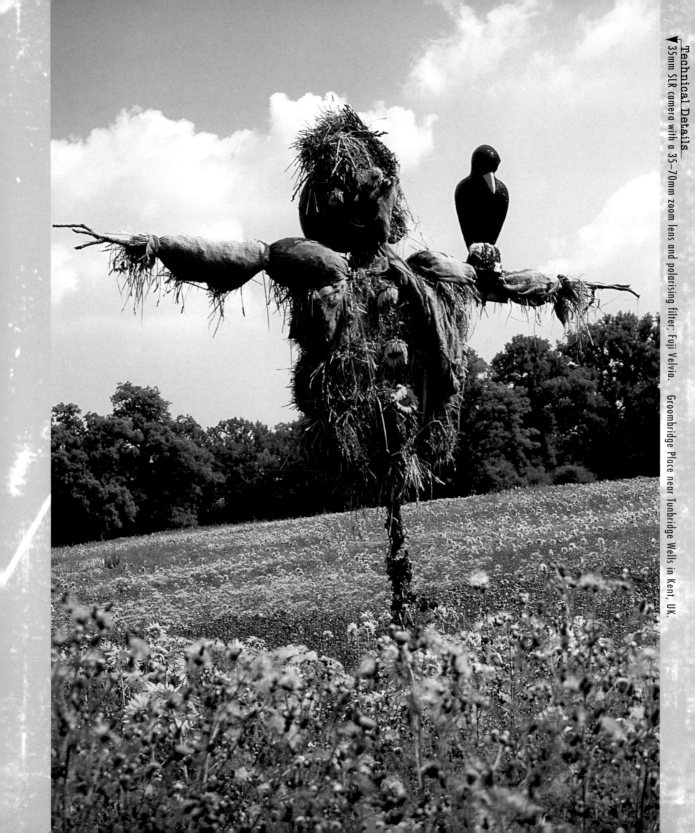

Technical Details
▼ 35mm SLR camera with a 35–70mm zoom lens and polarising filter; Fuji Velvia. Groombridge Place near Tunbridge Wells in Kent, UK.

The Vegetable Garden

Flowers and shrubs are by no means the only subjects of photographic interest in a garden — fruit and vegetables can also provide a wealth of visual possibilities. They invariably have very pleasing shapes, colours and textures which can be used to create quite striking images, either when photographed *in situ* or as arranged still lifes or close-ups.

Seeing

This still-life photograph was taken to illustrate a brochure to suggest the use of home-grown food. In fact, the vegetables all came from a local supermarket and the wooden trug was borrowed from a garden centre.

Thinking

Needing to find a suitable background for the set-up, I visited a local allotment and found this immaculate vegetable garden, the owner of which was happy to let me set up my shot in front of his impressive bean row.

Acting

I used a small wooden table as a means of placing the arrangement at a suitable height and chose a position so the sunlight was at the most effective angle. The shadows it cast were, however, rather too dense, so I placed a large white reflector on the shadowed side of the set-up to throw some light back into them and reduce the contrast of the image. I used a small aperture as I wanted the bean row in the background to be as sharp as possible.

Tapeley Park, Instow in North Devon, UK.

This shot of apples on a tree by Julien Busselle has a quite powerful effect, largely because of the very limited colour range and the colour density and saturation. Shooting almost directly upwards, Julien has placed the very green apples and foliage against a deep blue sky which he's accentuated further by the use of a polarising filter.

Technical Details ▶

6 x 4.5cm SLR camera with a 105–210mm zoom lens and polarising filter; Fuji Velvia.

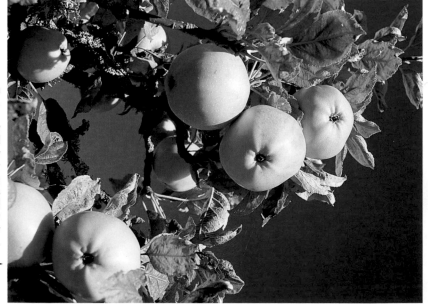

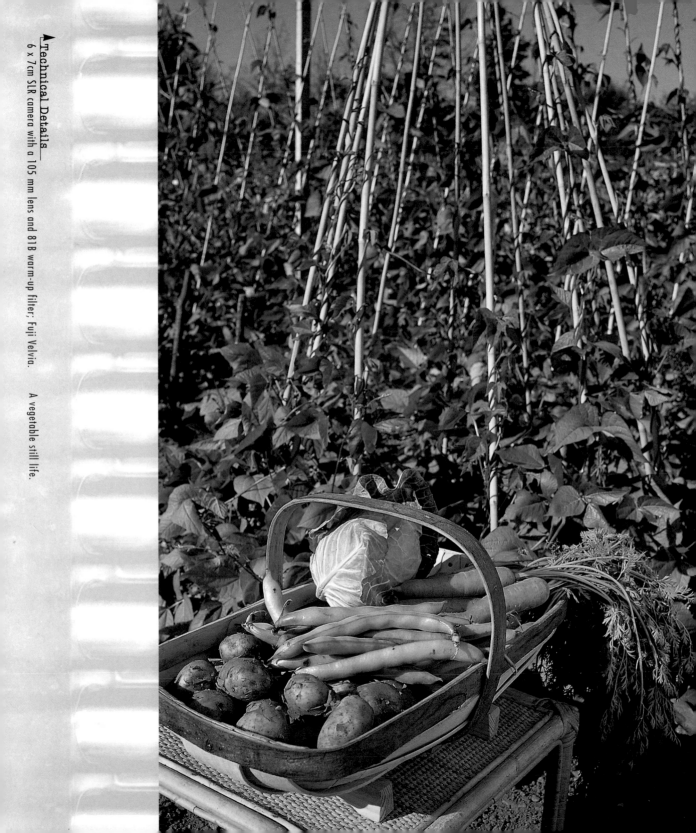

▲Technical Details
6 x 7cm SLR camera with a 105 mm lens and 81B warm-up filter; Fuji Velvia.

A vegetable still life.

Plants & Flowers in the Wild

Most photographers who are inspired by the possibilities afforded by a garden find wild plants and flowers equally appealing. In some ways such photography can be less restricting as photographing a garden sometimes involves obtaining permission, invariably with restricted access, and there is often the presence of other garden visitors to contend with.

Seeing

It was a late spring evening as I drove through this small valley and saw this luxurious growth of milk parsley. The lighting seemed very atmospheric and I was attracted by the almost monochromatic quality of the scene.

Thinking

The trees silhouetted on the distant ridge were very pleasing and I like the element of contrast which the pinkish tinge in the sky provided.

Acting

In order to include as much of the foreground as possible together with the distant horizon, I needed to use my wide-angle lens, choosing a viewpoint which placed the most attractive area of the foreground against the most prominent section of the silhouetted trees. I used a small aperture to ensure that both near and far details were recorded in sharp focus.

A clump of buttercups.

This natural arrangement of buttercups was found growing beside a dry-stone wall in Derbyshire. It appealed to me because of the very limited colour range and the fact that the flowers were highlighted by the sun and thrown into strong relief by the shaded wall. I used a widish aperture so the background details remained in soft focus and did not become too distracting.

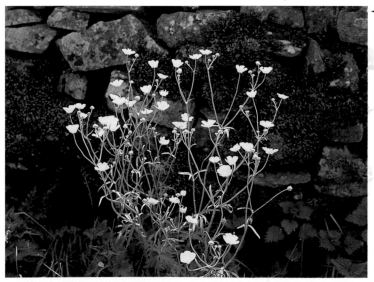

◄ Technical Details
6 x 4.5cm SLR camera with a 105–210mm zoom lens and 81B warm-up filter; Fuji Velvia.

Notice how the position of the sun enabled the flowers to be illuminated while the wall remained in shadow.

Technical Details
▼ 6 x 4.5cm SLR camera with a 35mm wide-angle lens, 81B warm-up and neutral-graduated filters; Fuji Velvia.

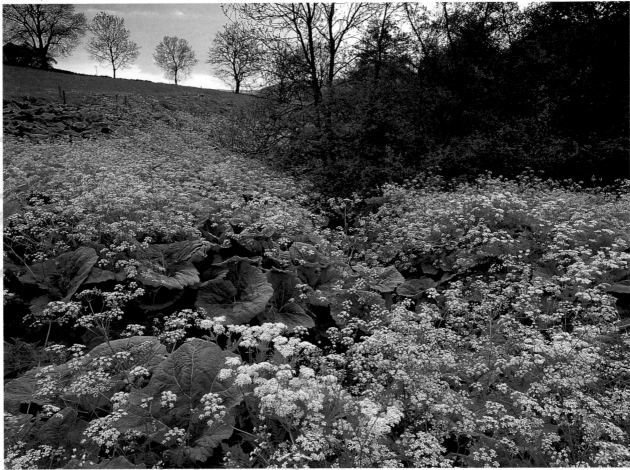

A river near Dovedale in Derbyshire, UK.

Technique

A bright sky often needs less exposure than the foreground, and to avoid it recording too light and lacking in tone and detail you can use a neutral-graduated filter to reduce the exposure in this area alone.

Plants & Flowers in the Wild

Seeing

The colourful carpet of flowers in this meadow was visible from some distance away, but it wasn't until I got closer that I saw the small stone barn.

Thinking

A suitable focus of attention is often hard to find for pictures of this type and the small building seemed like a godsend. I walked into the field to look for a particularly dense area of colour where the flowers were also in good condition – poppies can very quickly become ragged and unattractive.

Acting

Having found what I thought was the best spot, I looked for a viewpoint which would place the flowers in the most effective juxtaposition to the distant building. I found that by placing the camera quite low to the ground, I could make the floral colour appear even more concentrated, and I framed the shot so that a small section of the sky was included and the stone barn was placed just off-centre. I used an 81EF warm-up filter and a neutral-graduated filter to make the blue sky a little darker.

A meadow near the town of Apt in Provence, France.

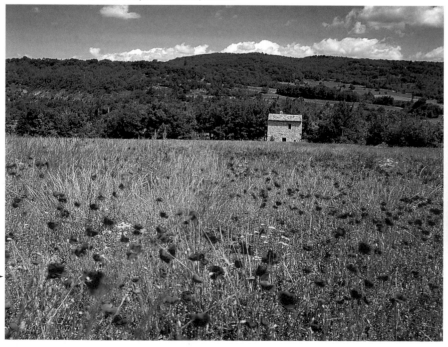

Technical Details
6 x 4.5cm SLR camera with a 55–110mm zoom lens, polarising, 81EF warm-up and neutral-graduated filters; Fuji Velvia.

Technical Details

▼ 6 x 4.5cm SLR camera with a 105–210mm zoom lens and 81B warm-up filter; Fuji Velvia.

The Darent Valley near Shoreham in Kent, UK.

Seen on the edge of a field of ripening barley, these few poppies seemed to gain in impact simply because they were quite small splashes of bold colour against the much larger area of pale gold wheat. I chose a viewpoint and framed the image so the poppies and small area of grass were towards the bottom of the frame and created what I felt was a pleasing balance.

Light & the Image

3

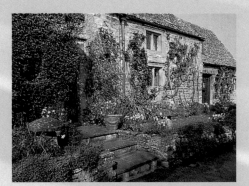

The quality and direction
of light are the two most important factors in creating the mood of an
image. From shooting in sunlight to dealing with overcast days, bad
weather and the changing seasons, this chapter shows you
how to make the best of every situation.

Shooting in Sunlight

Although most people would choose a sunny day to visit a garden, bright sunlight can produce unattractive effects if some care is not taken over the choice of viewpoint and the way the image is framed. This can be especially true of very bright summer days when the sky is a deep blue and there are no clouds to soften it or to reflect light into the shadows.

Seeing

It was partly the shadows created by the sunlight which attracted Julien Busselle to this scene as they emphasised the receding pathway and heightened the feeling of depth which this creates.

Thinking

The trees helped to accentuate the receding perspective, and Julien took up a position in the centre of the pathway where the effect was most noticeable.

Technical Details
▼ 6 x 4.5cm SLR camera with a 105–210mm zoom lens and 81B warm-up filter; Fuji Velvia.

Squerryes Court, Westerham in Kent, UK.

The striking effect in the photograph of this sambuccus by Julien Busselle is the result of shooting into the light and by the very limited colour range of the image. By choosing the right viewpoint Julien was able to place the back-lit foliage against a virtually black, shadowed background, creating an almost luminous quality.

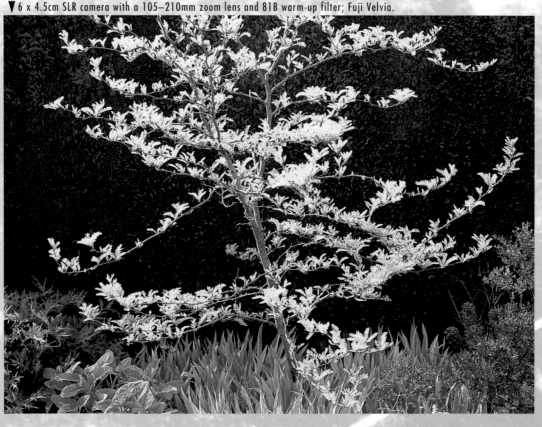

Acting

Julien framed the image as an **upright** and used a wide-angle lens to include the closest branch of the nearest tree, providing a **frame** which helps to direct the interest to the main area of the image and has masked the rather **weak sky**.

Technical Details

▼ 6 x 4.5cm SLR camera with a 55–110mm zoom lens; Fuji Velvia.

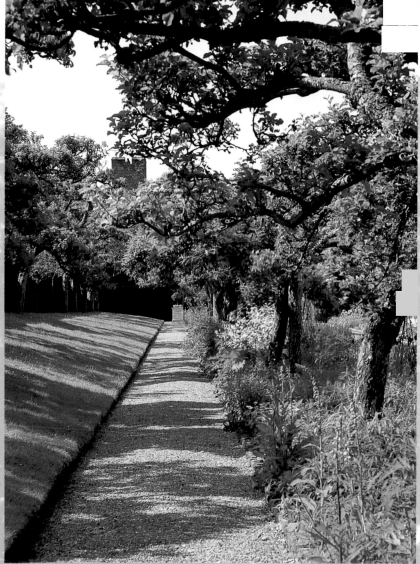

Penshurst Place gardens near Tonbridge in Kent, UK.

See how the shadows have helped to create the impression of perspective and emphasised the structure of this image.

Controlling Contrast

The right level of contrast is very important in colour photography. Too little and the image will appear flat and lacking in colour saturation, too much, and the photograph will be harsh and unappealing, and the subtlety of the colours will be lost.

Seeing

This colourful display of rhododendrons in a woodland garden made an **obvious subject** for a photograph, but the **direct sunlight** of a bright spring day was very hard and there were **dense shadows** which raised the level of contrast to an unacceptable degree.

Thinking

I looked for a **viewpoint** from where the shadows would occupy the **smallest area** and which also placed the most **colourful blooms** together effectively.

Acting

I used my long-focus lens to frame the image **very tightly**, concentrating on the section of the scene where the subject consisted mainly of the **lighter tones**. I used a polarising filter to increase the **colour saturation** and to subdue the highlights, which reduced the contrast further.

Technical Details

▼ 35mm SLR camera with an 80–200mm zoom lens, polarising and 81C warm-up filters; Fuji Velvia.

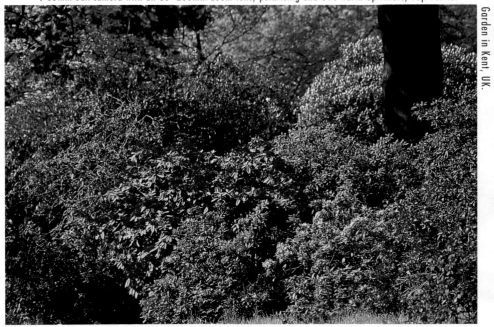

Garden in Kent, UK.

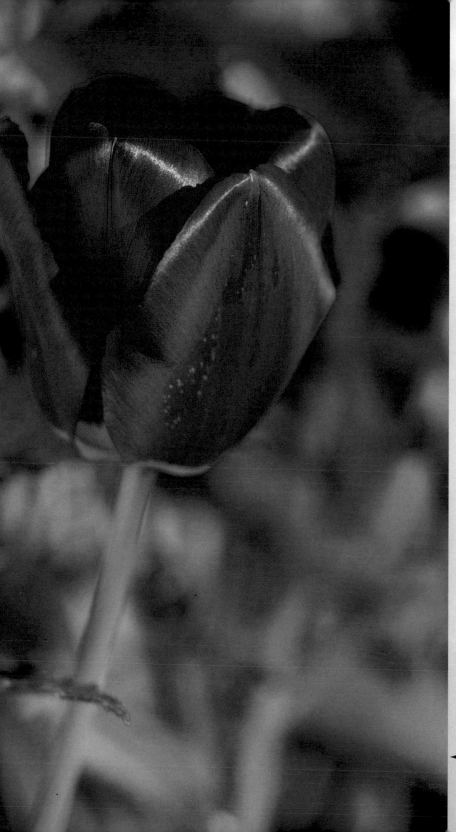

See how the reflector card was placed to reduce the density of the shadows.

Close-up shot of a tulip.

Direct sunlight had created a considerable amount of contrast on this close-up of a tulip and the quality of its colour was greatly diminished because of the dense shadows it created. I used a piece of white card placed very close to the bloom on the shaded side to bounce light back into the shadows, which has almost eliminated them.

Technique

It can help you judge the contrast of a scene if you view it through half-closed eyes or through the viewfinder of an SLR camera with the lens stopped down.

Although the subject, together with the angle and quality of light, is largely responsible for establishing the contrast of an image, considerable control can be achieved by the choice of viewpoint and the way in which the image is framed.

Technical Details
6 x 4.5cm SLR camera with a 105–210mm zoom lens and an extension tube; Fuji Velvia.

Shooting on Cloudy Days

Although a hazy or overcast day may seem less than ideal for photography, it can be preferable for many subjects. Very brightly coloured subjects or those with lots of fine detail will often photograph more successfully when lit by the softer light of a cloudy day. Close-up photographs, in particular, often benefit from being photographed with a more diffused light.

Seeing

My visit to these gardens was on a very overcast day which in some ways restricted my choice of subjects. Although the lighting was ideal for fairly close-up images, I was also keen to produce photographs which showed more of the gardens' character and landscape.

Thinking

I felt that by careful selection and tight framing I could find sections of the garden where the inherent contrast of the scene would make up for the soft lighting and produce images with some impact.

Acting

I found this viewpoint from where, with the aid of a long-focus lens, I was able to isolate a small area of the garden where the colourful flowers and light-toned statues provided enough contrast to create a punchy image.

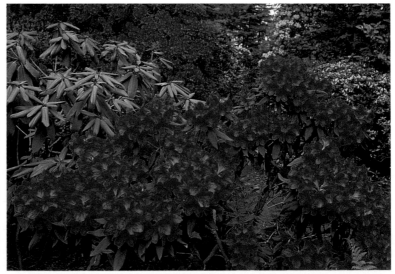

Close-up shot of rhododendrons.

The very soft light of an overcast day was the perfect illumination for this close-up shot of rhododendrons. I framed the shot tightly to exclude all but the colour of the blooms and a small area of leaf for contrast and took care to make sure that the featureless, white sky was excluded. I used a small aperture to ensure there was adequate depth of field.

Technical Details
35mm SLR camera with a 75–300mm zoom lens
and 81C warm-up filter; Fuji Velvia.

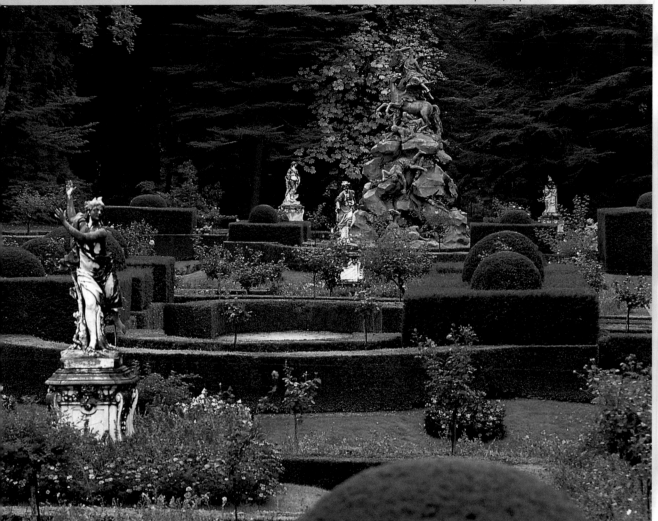

The gardens of San Idelfonso la Granja near Segovia in Castile, Spain.

Technical Details
6 x 4.5cm SLR camera with a
55–110mm zoom lens; Fuji Velvia.

Rule of Thumb

Hazy and overcast days usually have very pale milky
skies, and these can have a very negative effect on
colour photographs when shooting views or distant
scenes. It is best if you can find viewpoints and frame
your pictures to exclude the sky. It can also sometimes
help, especially if there is some tone in the sky, to use a
neutral-graduated filter to make it darker.

The Time of Day

The time of day can have a considerable effect on the quality and mood of a photograph. In the middle of the day the sun reaches its highest peak and the shadows are at their smallest. The colour quality of the light at this time is also at its bluest. Earlier and later in the day the light has a much warmer quality and the shadows lengthen. Also, of course, during the passage of the day the angle of the sun in relation to a particular view changes by almost 180 degrees in high summer.

Technical Details

▼ 6 x 4.5cm SLR camera with a 55–110mm zoom lens and 81B warm-up filter; Fuji Velvia.

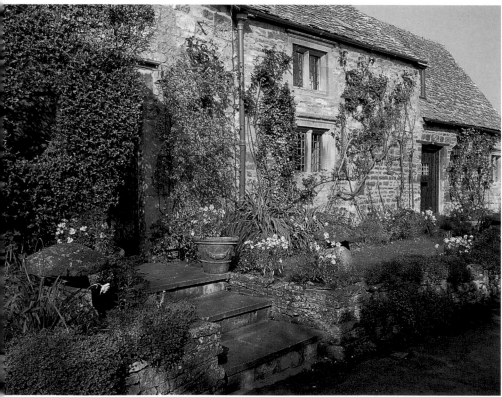

A cottage in the Cotswolds, UK.

I'd seen this Cotswold cottage on the previous day when the light had been at a different angle and the front was in deep shade. I made a point of returning the next morning as soon as the sun came up and found the lighting was now ideal.

Rule of Thumb

The warm light at the beginning and end of the day can be particularly effective for photographing buildings and features like walls and ornaments because the lower colour temperature of this light brings out the rich colour and texture of old stone.

Technical Details

▼ 35mm SLR camera with an 80–200mm zoom lens, polarising and 81C warm-up filters; Fuji Velvia.

The warm light of the sun at the very end of the day has accentuated the rich colour of the autumn foliage in this shot, as well as helping to create an atmospheric image.

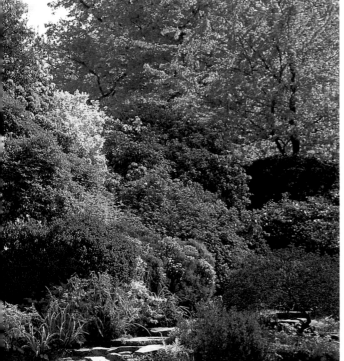

The gardens of Hever Castle near Edenbridge in Kent, UK.

During the first part of my visit to this garden, in the early morning, the lighting on this magnificent display of Rhododendrons had been unattractive as it had cast some quite deep shadows within the banks of foliage and bloom, and had created considerable contrast. But when I returned a few hours later the sun was higher in the sky and the shadows had become much smaller and were no longer too dominant.

Technical Details ►

6 x 4.5cm SLR camera with a 105–210mm zoom lens and 81B warm-up filter; Fuji Velvia.

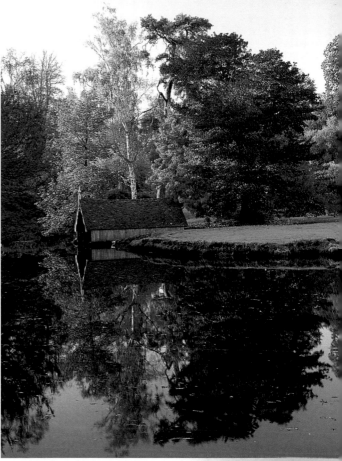

The gardens of Scotney Castle near Tunbridge Wells in Kent, UK.

Light & Colour

The colour quality of daylight varies considerably according to the position of the sun in the sky and factors like cloud and blue sky. In the middle of a summer's day, when there is a deep blue sky, the light can be much bluer than that for which the film is balanced. Likewise, shooting subjects in open shade and on a cloudy overcast day can create an unpleasant blue cast on transparency film. On the other hand, early morning and late afternoon sunlight can be much yellower than that for which the film is balanced and this can create a warm colour cast.

Seeing

The back lighting created a very attractive quality in this autumnal scene. It was quite early in the morning and the sunlight had a warmth which accentuated the colour of the red leaves and golden grasses.

Thinking

I realised that the deeply shaded background had a quite pronounced blue cast because of light reflected from the blue sky and felt that this provided an effective contrast with the warm foreground colours.

Technical Details
6 x 4.5cm SLR camera with a 105–210mm zoom lens; Fuji Velvia.

Garden in Kent, UK.

Acting

I decided to use a long-focus lens to isolate the most colourful area of the foreground and chose a viewpoint which placed it in the most effective juxtaposition to the shadowed background.

Nymans garden, near Haywards Heath in West
Sussex, UK.

This photograph was taken in late afternoon
when the colour quality of the light was very
warm. This has accentuated the rich red tones
of the autumn foliage.

Technical Details
6 x 4.5cm SLR camera with a 105–210mm
zoom lens, polarising and 81A warm-up filters;
Fuji Velvia.

Technical Details
6 x 4.5cm SLR camera with a 105–210mm zoom lens and 81C warm-up filter; Fuji Velvia.

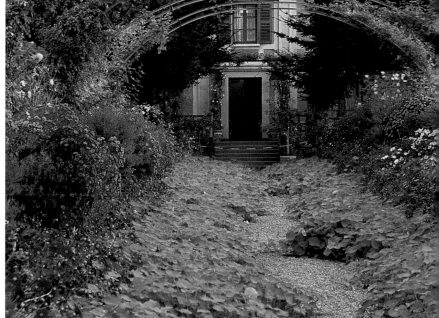

Monet's Garden at Giverny near Vernon in Normandy, France.

This shot was taken on a very overcast day when the colour
temperature of the light was quite high. This would have created
a distinctly blue cast so I used an 81C warm-up filter to
counteract this and framed the image quite tightly to fill the
frame with the greatest concentration of colour and to eliminate
the featureless white sky.

Light & Colour

Seeing

This photograph was taken in the open shade on a sunny day with a blue sky and the colour quality of the light was quite blue.

Thinking

It was the contrast between the vivid autumnal colours of the boston ivy and green leaves of the hydrangeas which appealed to me and I thought that this might be diminished if I used a warm-up filter.

Rule of Thumb

When photographing close-up images of flowers which have very warm colours, such as oranges, reds and yellows, it's often best either not to use warm-up filters at all, or to use only very weak ones, even on overcast days or in open shade, as the effect can be too strong.

Technical Details

▼ 6 x 4.5cm SLR camera with a 55–110mm zoom lens; Fuji Velvia.

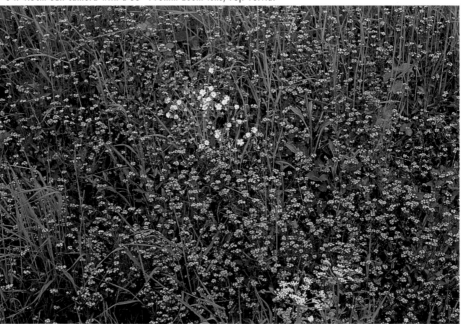

Hedgerow in Burgundy, France.

I found this clump of forget-me-nots in a hedgerow while driving through the countryside in Burgundy in France. on a cloudy day. It was the overall bluishness of the subject which appealed to me and, although I could have used a warm-up filter to correct this, I felt the image would benefit from having a cool, blue quality.

Technical Details
▼ 6 x 4.5cm SLR camera with a 105–210mm zoom lens; Fuji Velvia.

Acting

I decided to shoot the picture **without a filter** but to
frame the image very tightly so that the picture was almost filled
by the green and red leaves. The resulting **blue cast** has
had little significant effect on the red leaves but has given the
green leaves a distinctly bluish quality which, I think,
increases the contrast between them.

The Weather

A warm, sunny summer's day is the sort of occasion upon which most photographers would think of heading off to shoot pictures of a garden. But weather conditions such as fog, frost and stormy skies can give an image an instantly eye-catching quality and create a degree of interest and impact which can be lacking in the more bland light of a perfect sunny day.

Seeing

This woodland garden had been transformed by the fog in this picture taken by Julien Busselle. On a previous visit he had shot pictures in sunlight which were very pleasing but on this occasion there was far more atmosphere.

Thinking

Julien decided to make a skimmia bush the main feature of this shot because the bold colour provides an essential element of contrast together with the dark tree trunk on the right-hand side of the frame.

Acting

He used a long-focus lens to isolate a small area of the scene and chose a viewpoint which included the more distant semi-silhouetted trees, framing the image quite tightly to emphasise the strong colours and shapes.

Technical Details
35mm SLR camera with a 75–300mm zoom lens and 81B warm-up filter; Fuji Velvia.

Rule of Thumb

Bad weather conditions like fog and overcast skies often result in a lack of contrast. To overcome this you can choose viewpoints and frame your pictures in such a way that the darkest tones and richest colours are placed quite close to the camera. Brightly coloured flowers, for instance, or the silhouetted branches of a tree in the foreground, can considerably increase the contrast of an image.

Marwood Hill near Barnstaple in North Devon, UK.

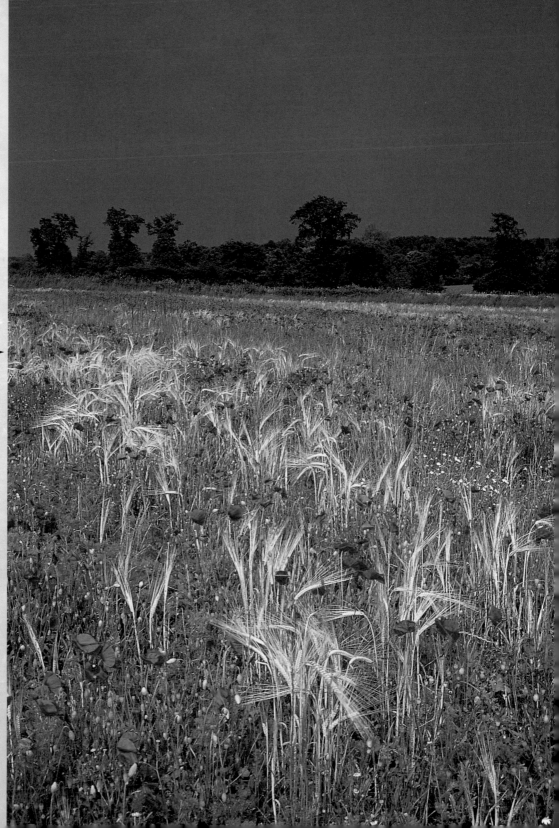

Near Chateau Meillant in the department of Cher, France.

This shot of a summer meadow filled with wild flowers was taken very shortly after a storm had cleared, and the combination of the sunlit foreground flowers and the dark stormy sky above has given the image considerable impact. I used a wide-angle lens to allow the inclusion of close foreground details and a neutral-graduated filter to emphasise the dark sky.

► Technical Details
35mm SLR camera with a 20–35mm zoom lens, 81B warm-up and neutral-graduated filters; Fuji Velvia.

The Seasons

One of the most appealing aspects of garden photography is the constant changes which take place as the year progresses. The effects of the seasons are, of course, visible generally in the countryside but gardens are designed and planted with these changes in mind. It's possible to visit the same garden at intervals throughout the year and find it very different on each occasion.

A Year in a Garden

Photographing a garden year can be a very satisfying way of building a collection of photographs, whether it is on visits to the same garden or by choosing gardens which reach their peaks at particular times of the year.

Seeing

I saw this small Sussex cottage garden as I walked along the street and was immediately struck by the beautiful summery quality of its colour and of the light.

Thinking

I wanted to capture the smallness and intimacy of the space and decided to make use of the wrought-iron gate in the foreground.

Acting

I chose a viewpoint which allowed me to include part of the gate with a wide-angle lens and to frame the shot so that just the top was visible along with the roses on the left-hand side of the picture.

Technical Details

▼ 35mm SLR camera with a 20–35mm zoom lens and 81B warm-up filter; Fuji Velvia.

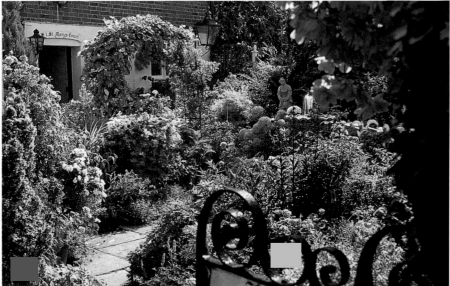

Cottage garden in Sussex, UK.

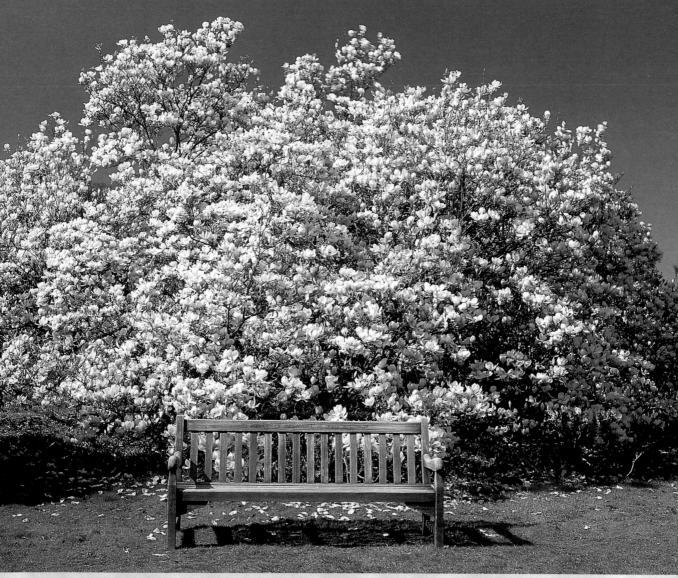

Rule of Thumb

When shooting subjects which have a large area of very light tones, like this shot of the magnolia tree, it's necessary to increase your exposure because a normal exposure reading will interpret the scene as being brighter than it really is and indicate less exposure than is actually needed.

Emmett's Gardens near Sevenoaks in Kent, UK.

I decided to adopt a very straightforward approach to photographing this magnificent magnolia tree. I was lucky because the sunlight was at the perfect angle from this viewpoint, giving me a front-on view of the tree with the bench in the centre. The cloudless blue sky above was a bonus because it kept the image very simple. I used a polarising filter to increase the colour saturation of the sky and create stronger relief with the blooms. I gave two-thirds of a stop extra exposure to allow for the large area of very bright flowers.

Seeing

I was driving through a small valley in the French Pyrenees when I saw this prunus orchard in late autumn. Although it was a cloudy, overcast day, the soft light had made the rich gold of the leaves appear almost luminous.

Thinking

I felt that the most striking effect would be achieved by filling the frame with the colour of the foliage and looked for a section of the orchard where this was densest.

Acting

I chose this viewpoint because the shapes created by the branches and trunks of the trees created a very pleasing arrangement, and I liked the small intrusion of green grass on the left-hand side of the shot. I used my zoom lens to frame the image quite precisely, excluding the white, featureless sky above the tree tops.

Prunus orchard in the Pyrenees, France.

▲ Technical Details
6 x 4.5cm SLR camera with a 105–210mm zoom lens and 81B warm-up filter; Fuji Velvia.

▲ Technical Details
6 x 4.5cm SLR camera with a 105–210mm zoom lens and 81B warm-up filter; Fuji Velvia.

The North Downs in Kent, UK.

Great drifts of old man's beard cover the North Downs near my home in Kent in early winter, and I couldn't resist taking this shot. There was a very soft hazy sunlight and I took this picture towards the light using a viewpoint which placed the red and gold autumnal foliage behind to create a contrasting background. I used a long-focus lens to frame a small section of the bush and chose a fairly wide aperture so the background details were slightly out of focus and not too distracting.

The Seasons

Garden in Kent, UK.

Seeing

A hoar frost had blanketed this woodland garden when I visited it early on a winter morning. I discovered this group of leaves which were in good condition and nicely arranged – the frost made it impossible to do any rearranging without marking it.

Thinking

I wanted to shoot a close-up image so that the texture of the frost would be visible, and as this would give me a very limited depth of field, I opted to use an overhead viewpoint so that the leaves were on a parallel plane to the camera.

Acting

I moved my tripod and adjusted the zoom until I had the group of leaves arranged within the frame to my liking. The sun was just beginning to rise enough to reach the leaves and I waited until they were just tinged with sunlight before shooting.

Garden in Kent, UK.

Technical Details
6 x 4.5cm SLR camera with a 105–210mm zoom lens and extension tube; Fuji Velvia.

A heavy fall of snow can seriously limit the possibilities of garden photography, but the red berries of this cotoneaster peeping through the snow-covered branches were just prominent enough to make the image work. I framed the picture tightly, isolating the most concentrated area of berries, and gave a half stop extra exposure to compensate for the bright snow.

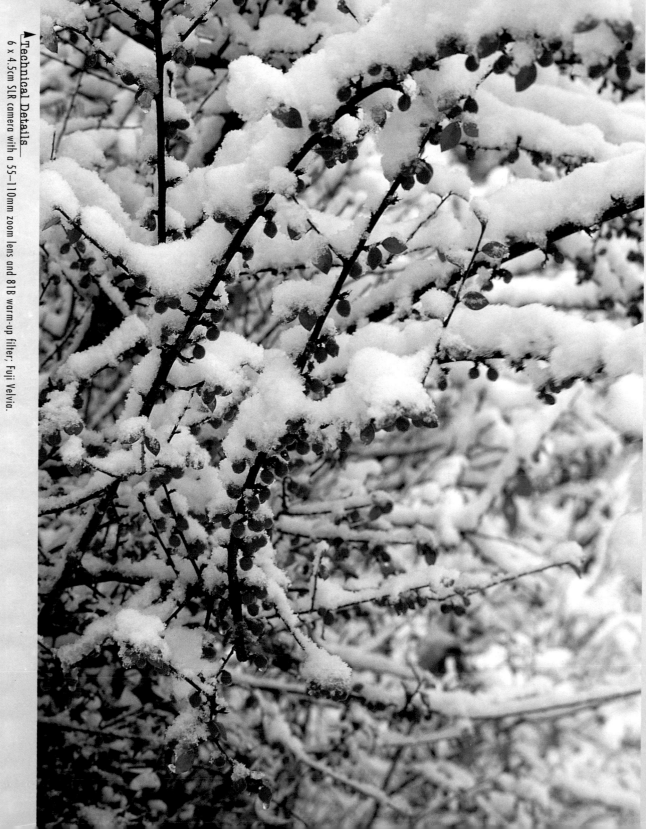

▲Technical Details
6 x 4.5cm SLR camera with a 55–110mm zoom lens and 81B warm-up filter. Fuji Velvia.

Cameras & Equipment

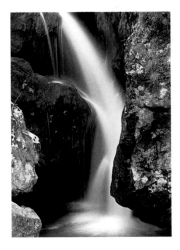

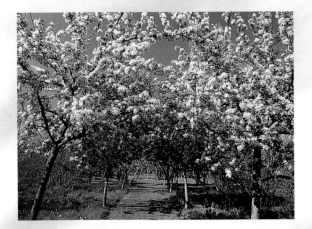

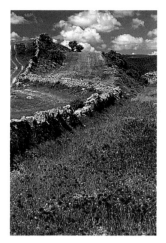

4

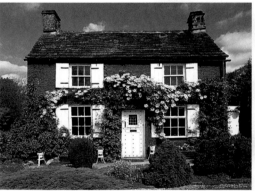

The choice of cameras, lenses and accessories will determine, to a large extent, the type of subjects you can photograph successfully. This chapter helps you make the right choice of equipment for your own particular needs and explains how to use it to produce the most telling results.

Choosing a Camera

The choice of camera type and format for flower and garden photography depends upon a number of factors. Versatility is one of the most important, since photographing a garden can involve such widely varying subjects as landscapes, buildings, still lives, details and close-ups.

Formats

Image size is the most basic consideration. The image area of a 35mm camera is approximately 24 x 36mm but with roll-film it can be from 45 x 60mm up to 90 x 60mm according to camera choice. The degree of enlargement needed to provide, say, an A4 reproduction is considerably less for a roll-film format than for 35mm and gives a potentially higher image quality.

For most photographers the choice is between 35mm and 120 roll-film cameras. Advanced Photo System (APS) cameras offer a format slightly smaller than 35mm while for images larger than 90 x 60mm it is necessary to use a view camera using sheet film of 5 x 4in or 10 x 8in format.

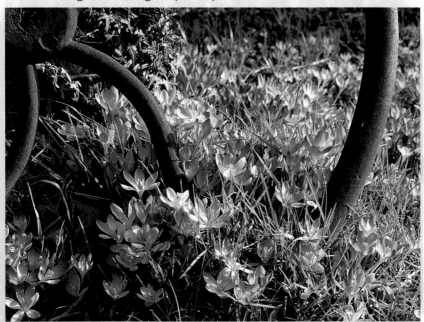

Autumn crocuses in Kent, UK.

This shot of autumn crocuses benefits from the use of a medium-format camera with the greater image quality which roll-film transparencies and negatives can offer. This format is ideal for those wishing to see their work in print, for high-quality projection and for producing large prints.

▲ Technical Details
6 x 4.5cm SLR camera with a 105–210mm zoom lens; Fuji Velvia.

Pros & Cons

APS cameras have a more limited choice of film types and accessories and are designed primarily for the use of print film. 35mm **Single Lens Reflex** (SLR) cameras are provided with the **widest range** of film types and accessories and provide the best compromise between image quality, size, weight and cost of equipment.

Both **accessories and film** are significantly more expensive with **roll-film cameras** and the range of lenses and accessories is more limited than with 35mm equipment. Some facilities, such as autofocus and motor drive, are not available on many roll-film cameras, and these cameras are also generally **heavier and bulkier** than 35mm cameras. View cameras provide extensive perspective and depth-of-field control and are especially useful for architectural and still-life photography but are cumbersome and not user friendly.

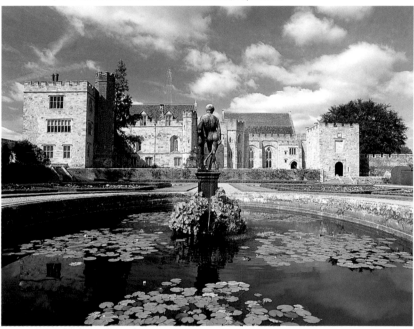

Penshurst Place near Tonbridge in Kent, UK.

A shot like this, taken using a very wide-angle lens, requires a camera with interchangeable lenses. These can be significantly less expensive for 35mm cameras than for medium-format ones.

The village of Vieux Port near Rouen in Normandy, France.

A fairly simple APS or 35mm compact camera is ideal for shots like this taken in good light, when colour negative film is used and prints of no larger than about 10 x 8in are required.

▲ Technical Details
35mm compact camera with a 35–70mm zoom lens ; Fuji Super G 200.

Annual cosmos, UK countryside.

An SLR camera is ideal for shots like this close-up of the annual cosmos because the effect of focusing can be seen clearly whereas a viewfinder camera shows the entire image as sharp regardless of where it is focused. An SLR camera with a depth of field preview button will make it easier to judge the effect of focusing when using different apertures.

▲ Technical Details
35mm SLR camera with an 80–200mm zoom lens; Fuji Velvia.

Camera Types

There are two basic choices for both roll-film and 35mm cameras: the viewfinder (rangefinder) camera and the Single Lens Reflex (SLR).

Pros & Cons

An SLR camera allows you to view the actual image which is being recorded on the film while a viewfinder camera uses a separate optical system. The effect of focusing can be seen on the screen of an SLR but the whole image appears in focus when seen through a viewfinder camera.

Generally, facilities like autofocus and exposure control are more accurate and convenient with SLR cameras and with them you can see the effect of filters and attachments – which you can't do with a viewfinder. SLR cameras have a much wider range of accessories and lenses available and are more suited to subjects like wildlife which demand very long-focus lenses and close-ups. However, viewfinder cameras tend to be lighter and quieter than SLRs.

A bluebell wood near Ashford in Kent, UK.

The elongated format of a panoramic camera does not suit every subject, especially when using the more extreme 6 x 17cm format, but it can be very effective.

Technical Details ▶
A 5 x 4in viewfinder camera fitted with a 6 x 12cm roll-film back; 90mm lens and Fuji Velvia.

Specialist Cameras

While it's possible to produce **panoramic** format photographs with some ordinary APS cameras, 35mm and roll-film cameras, dedicated 6 x 12cm, 6 x 17cm and 6 x 24cm cameras are the professional's choice, particularly for garden landscapes. These are essentially **viewfinder** cameras taking 120 with a greatly elongated film chamber. Some have fixed wide-angle lenses while others have interchangeable lenses. An alternative to using a dedicated panoramic camera is to use a 6 x 12cm roll-film back with a 5 x 4in view camera.

In addition to conventional panoramic cameras there are also **swing-lens cameras**, such as the Widelux, giving a panoramic image over a wide angle of view. These can be bought in both 35mm and 120 film formats and have a moving lens mount which progressively exposes the film. This gives a more limited range of shutter speeds and also causes **horizontal lines to curve** if the camera is not held completely level.

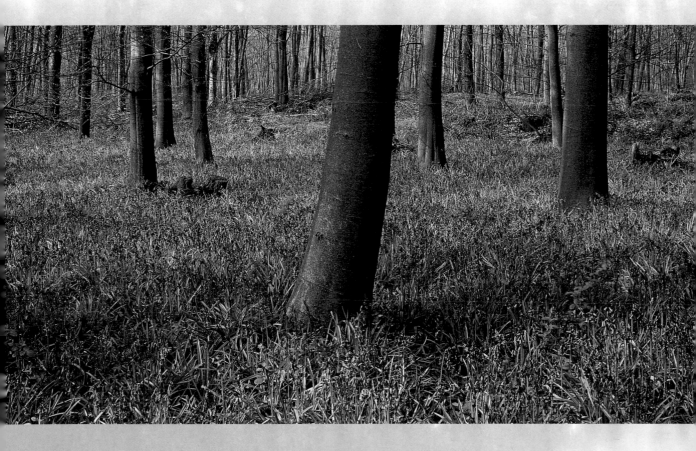

Choosing Lenses

A standard lens is one which creates a field of view of about 45 degrees and has a focal length equivalent to the diagonal measurement of the film format – 50mm with a 35mm camera and 80mm with a 6 x 6cm camera, for example.

Lenses with a shorter focal length create a wider field of view and those with a longer focal length produce a narrower field of view. Zoom lenses provide a wide range of focal lengths within a single optic, taking up less space and offering more convenience than having several fixed lenses.

Pros & Cons

Many ordinary zooms have a maximum aperture of f5.6 or smaller. This can be quite restricting when fast shutter speeds are needed in low light levels, and a fixed focal length lens with a wider maximum aperture of f2.8 or f4 can sometimes be a better choice. Zoom lenses are available for most 35mm SLR cameras over a wide range of focal lengths but it's important to appreciate that the image quality will drop with lenses which are designed to cover more than about a three-to-one ratio, i.e. 28–85mm or 70–210mm.

Technical Details
35mm SLR camera with 20mm and 200mm lenses; Fuji Velvia.

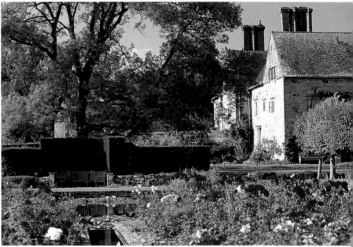

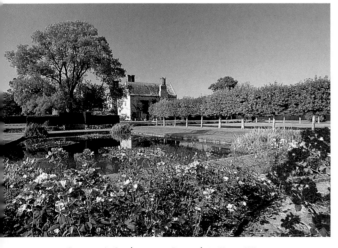

Bateman's Gardens near Burwash in Kent, UK.

These two photographs of Bateman's House, where Rudyard Kipling lived, were taken from the rose garden at the same distance, but from a slightly different angle. They show the striking effect which the different fields of view – produced by 20mm and 200mm lenses have on both the composition and the apparent perspective of the image.

Special Lenses

When photographing buildings, a perspective-control or shift lens can be a good investment. These allow the lens to be physically moved from its axis to allow the image to be moved higher or lower in the frame without the need to tilt the camera, thereby avoiding the converging verticals which this produces.

A macro lens is also very useful when photographing close-up images of flowers, making it possible to obtain life-sized images without the need for extension tubes or close-up attachments.

Extenders

Extenders can allow you to increase the focal length of an existing lens. a x 1.4 extender will turn a 200mm lens into 300mm and a x 2 extender will make it 400mm. There will be some loss of sharpness with all but the most expensive optics and a reduction in maximum aperture of one and two stops respectively.

Here you can see the angle of view for lenses of different focal lengths when used with a 35mm camera.

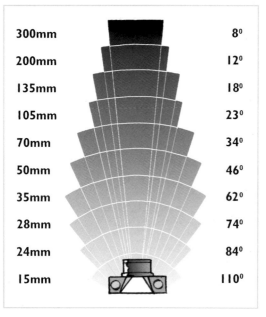

300mm	8^0
200mm	12^0
135mm	18^0
105mm	23^0
70mm	34^0
50mm	46^0
35mm	62^0
28mm	74^0
24mm	84^0
15mm	110^0

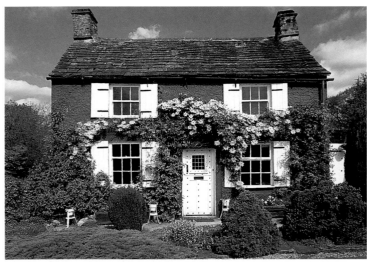

A cottage near Ashbourne in Derbyshire, UK.

Using a shift lens has enabled me to include the whole of this cottage with a minimum amount of foreground. Without it, I would have had to tilt the camera upwards which would have caused the sides of the house to converge and appear distorted.

◄ Technical Details
6 x 4.5cm SLR camera with a 50mm shift lens; Fuji Velvia.

Camera Accessories

There is a wide range of accessories which can be used to control the quality of the image and increase the camera's capability. Extension tubes, bellows units and dioptre lenses will all allow the lens to be focused at a closer distance than it's designed for. This can be useful for obvious close-up subjects like flowers.

Technical Details
▼ 6 x 4.5cm SLR camera with a 105–210mm zoom lens, an extension tube; Fuji Velvia.

Close-up of a gazania bloom.

The combination of a zoom lens and extension tubes allows a wide degree of control over both the image size and the distance between camera and subject when shooting close-ups, as in this picture of a gazania bloom.

Filters

A range of filters is essential for both colour and black-and-white photography and a **square filter system**, such as Cokin or HiTech, is by far the most convenient and practical option. These systems use a **universal filter holder** which is slipped on to a simple adaptor ring available in all lens-thread diameters. In this way the same filter holder can be fitted to all your lenses.

The most basic filter kit should include a set of warm-up filters, a graduated filter and a polarising filter. For those shooting black-and-white film, a few contrast filters, such as yellow or red, are a useful addition. Polarisers are available in either **linear or circular form**. The former can interfere with some auto-focusing and exposure systems. Your camera's instruction book should give you more details, but if in doubt, use a circular polariser.

Powerscourt Gardens near Wicklow in County Wicklow, Eire.

Although this photograph was taken in bright light, a tripod was essential as I had to use a slow shutter speed of 1/2 sec. This was the result of using a slow film of ISO 50 in conjunction with a polarising filter and a small aperture of f22 to obtain maximum depth of field.

Technical Details ►
6 x 4.5cm SLR camera with a 105–210mm zoom lens; Fuji Velvia.

A bellows unit for use with a 35mm SLR camera.

Technical Details
▼ 6 x 4.5cm SLR camera with a 105–210mm zoom lens; Fuji Velvia.

The woodland garden of Chateau Grand Puy Lacoste in the Medoc, France.

Although this scene appears quite brightly lit, it was, in fact, a very gloomy, overcast day and the dark, wooded setting, combined with the use of a slow film and a polarising filter, made the necessary exposure of two seconds impossible without a tripod.

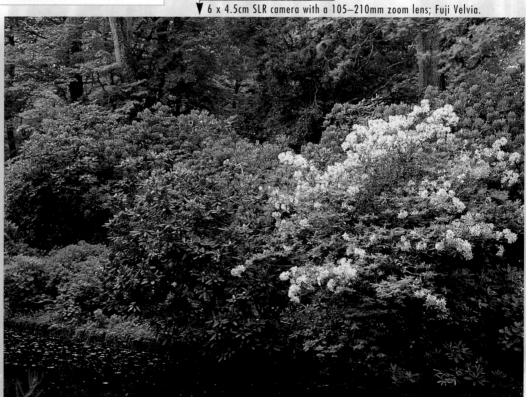

Tripod

Perhaps one of the most important accessories is a good solid tripod as it can greatly improve image sharpness allowing you to shoot pictures in low light levels and to use small apertures for greater depth of field. A shake-free means of firing the camera, such as a cable release or a remote trigger, is advisable when using a tripod-mounted camera.

Flash Guns

A separate flash gun is more useful than a built in flash. It will be much more powerful than one built in and it can be used off camera, fitted with a diffuser and used as a fill in to reduce contrast when shooting in bright sunlight.

Apertures & Shutter Speeds

The aperture is the device which controls the brightness of the image falling upon the film and is indicated by f stop numbers f2, f2.8, f4, f5.6, f8, f11, f16, f22 and f32. Each step down, from f2.8 to f4, for example, reduces the amount of light reaching the film by 50 per cent and each step up, from f8 to f5.6, for instance, doubles the brightness of the image.

The shutter speed settings control the length of time for which the image is allowed to play on the film and, in conjunction with the aperture, control the exposure and quality of the image.

Technique

Choice of aperture influences the depth of field, which is the distance in front and beyond the point at which the lens is focused. At wide apertures, such as f2.8, the depth of field is quite limited, making closer and more distant details appear distinctly out of focus.

The effect becomes more pronounced as the focal length of the lens increases and as the focusing distance decreases. So with, say, a 200mm lens focused at two metres and an aperture of f2.8, the range of sharp focus will extend only a very short distance in front and behind.

Here you can see the relationship between shutter speeds and apertures in terms of controlling the exposure. A one stop wider aperture needs a shutter setting of twice the speed to maintain the same exposure.

The depth of field increases when a smaller aperture is used and when using a short focal length or wide-angle lens. In this way a 24mm lens focused at, say, 50 metres at an aperture of f22 would provide a wide range of sharp focus, extending from quite close to the camera to infinity. A camera with a depth of field preview button will allow you to judge the depth of field in the viewfinder.

Rule of Thumb

When the lens is focused at normal distances the depth of field extends rather more behind the subject than in front. To obtain maximum depth of field, focus at a point about one third of the way between the closest and furthest details you want to be in sharp focus. When focusing on close-up subjects the depth of field is equidistant.

Mauve aubretia – effect of using different apertures.

These two pictures of mauve aubretia demonstrate how the depth of field is affected by the choice of aperture. The first picture was shot with the aperture wide open, providing only minimal depth of field, while the second picture was taken with the aperture set to f22, making the background details significantly sharper.

Technical Details
▼ 35mm SLR camera with an 80–200mm zoom lens; Fuji Velvia.

Apertures & Shutter Speeds

Shutter Speeds

The choice of shutter speed determines the degree of sharpness with which a moving subject will be recorded. With a fast-moving subject like a fountain, a shutter speed of 1/1000 sec or faster will be necessary to obtain a sharp image of the droplets.

In bright light it is not always possible to use very slow shutter speeds and there is an effective alternative method which involves making a number of exposures on the same frame using the camera's multi-exposure facility. If your exposure reading is, say, 1/30 at f16 you can give eight exposures of 1/250 sec at the same aperture or 16 exposures of 1/500 sec. The cumulative exposure will be the same but the moving part of the subject will create a similar effect to a very slow shutter speed.

Technique

A sharp image of a moving subject is not always the best way of photographing it, however, and in some circumstances a very slow shutter speed can be used to create striking effects. A classic example is a waterfall.

A tripod must be used to ensure the static elements of the image are recorded sharply and then a slow shutter speed of, say, one second or more can be selected to create a fluid smoke-like effect.

Rule of Thumb

The choice of shutter speed can also affect the image sharpness of a static subject when the camera is hand-held, as even slight camera shake can easily blur the image. The effect is more pronounced with long-focus lenses and when shooting close-ups. The safest minimum shutter speed should be considered as a reciprocal of the focal length of the lens being used – 1/200 sec with a 200mm lens, for instance.

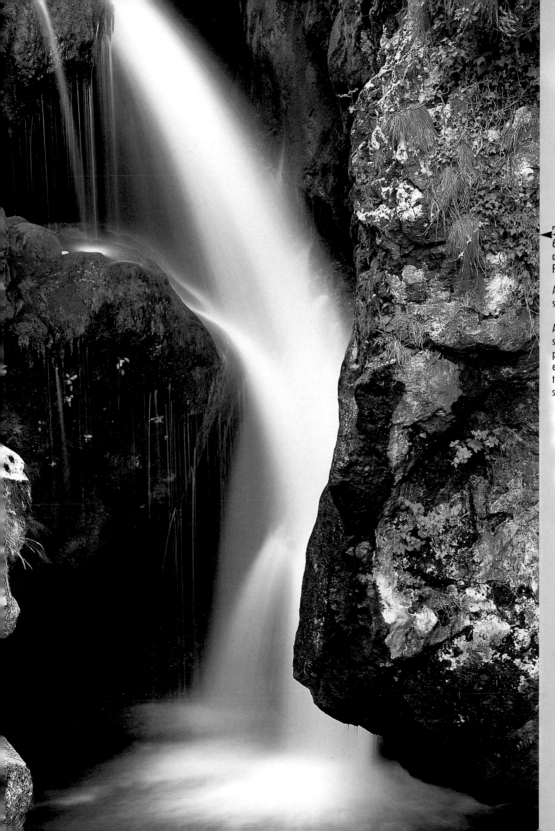

◄ **Technical Details**
6 x 4.5cm SLR camera with
a 105–210mm zoom lens;
Fuji Velvia.

A waterfall – slow shutter
speed.

A shutter speed of two
seconds was used for this
photograph of a waterfall,
enabling the moving water
to be recorded as a soft,
smoke-like blur.

Understanding Exposure

Modern cameras with automatic
exposure systems have made some aspects of achieving good-quality images
much easier, but no system is infallible and an understanding of how exposure
meters work will help to ensure a higher success rate.

An **exposure meter**, whether it's a built-in through-the-lens meter or a separate hand-held meter, works on the principle that the subject it is aimed at is a **mid-tone**, known as an **18 per cent grey**. In practice, of course, the subject is invariably a mixture of tones and colours but the assumption is still that, if mixed together, like so many pots of different-coloured paints, the resulting blend would be the same 18 per cent grey tone.

With most subjects the reading taken from the whole of the subject will produce a satisfactory exposure, but if there are aspects of a subject which are **abnormal** – when it contains large areas of very light or dark tones, for example – the reading needs to be **modified**.

An exposure reading from a **white wall**, for instance, would, if uncorrected, record it as **grey** on film. In the same way, a reading taken from a very dark subject would result in it being **overexposed** and appearing **too light** on the film.

▲Technical Details
35mm SLR camera with a 35–70mm zoom lens; Fuji Velvia.

Series illustrating the effects of
different exposures.

This series of photographs of a
border of petunias, pelargoniums and
verbena bonariensis was taken using
a bracket of five different exposures,
each varied by one-third of a stop
with the one in the centre given the
setting indicated by the exposure
meter. The frames which have had
more exposure show less colour
saturation and less detail in the
highlights, while the darker
exposures have stronger colour
saturation and more highlight detail
but less detail in the darker tones.

Understanding Exposure

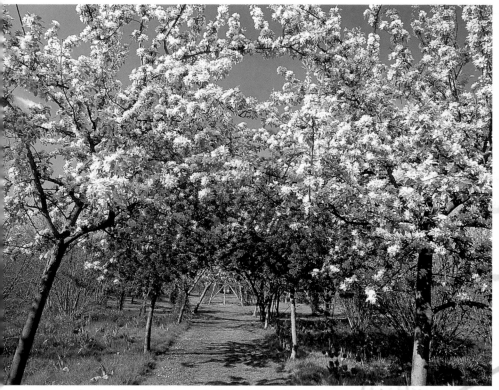

Sheffield Park Gardens near
Uckfield in Sussex, UK.

This scene possessed a normal
tonal range and was of average
contrast, so the exposure indicated
by the camera's TTL metering gave
a satisfactory exposure without
the need for compensation.

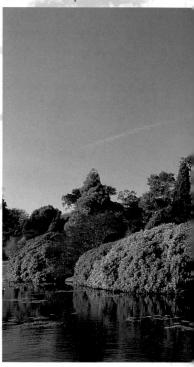

Penshurst Place Gardens near Tonbridge in Kent, UK.

I gave half a stop more than the meter suggested for this shot as the
large area of white spring blossom caused it to indicate less exposure
than was needed to record the scene satisfactorily.

▲Technical Details
6 x 4.5cm SLR camera with a 35mm lens; Fuji Velvia.

Chateau La Roche Courbon near Saintes in the Charente Maritime region of France.

I gave this photograph two-thirds of a stop less than was indicated by the exposure meter as it had allowed for the large area of dark foreground and the reading it suggested would have resulted in the main interest of the scene, the chateau, being overexposed.

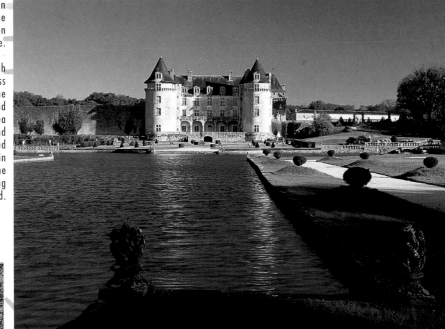

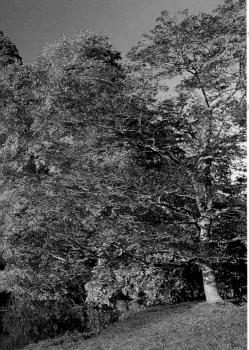

Technique

With negative films there is a latitude one stop or more each way and small variations in exposure errors will not matter but with transparency film even a slight variation will make a significant difference to the image quality and, where possible, it's best to bracket exposures, giving a third or half a stop more and less than that indicated, even with normal subjects.

Choosing Film

There is a huge variety of film types and speeds from which to choose and although, to a degree, it is dependent on personal taste, there are some basic factors to be considered.

<u>Technical Details</u>
▼ 6 x 4.5cm SLR camera with a 55–110mm zoom lens; Fuji Velvia.

Film Types

The choice between colour negative film and transparency film depends partly upon the intended use of the photographs. For book and magazine reproduction transparency film is universally preferred and transparencies are also demanded by most photo libraries. For personal use, colour negative film can be a better choice since it has greater exposure latitude and is capable of producing high-quality prints at a lower cost.

Although the photography of flowers and gardens make the use of colour film an obvious choice, there are many qualities in such subjects which can also be used to produce striking black-and-white images. In addition to conventional black-and-white films like Ilford's FP4 and Kodak's Tri X, there are also films such as Ilford's XP2 and Kodak's CN which use colour negative technology and can be processed in the same way at one-hour photo labs to give a monochrome image.

For those who like to experiment and produce images with a surrealistic quality, it can be interesting to use infrared film, available in both black-and-white and colour transparency versions, to create images with a most unusual range of tones and colours.

Rosemoor Gardens, Great Torrington in North Devon, UK.

A shot like this summer garden scene of lobelia cardinalis and dahlia, Bishop of Llandaff by Julien Busselle benefits from the use of a slow, fine-grained colour transparency film like Fuji Velvia as it produces very fine detail and rich, saturated colours. This makes it an ideal choice both for reproduction and for projection.

With all film types, the speed determines the basic image quality. A slow film of ISO 50, for instance, has finer grain and produces a significantly sharper image than a fast film of, say, ISO 800. With colour film the accuracy and saturation of the colours will also be superior when using films with a lower ISO rating.

Leeds Castle Gardens near Maidstone in Kent, UK.

For subjects like this spring scene, and when colour prints are the main requirement, colour negative film is ideal as it has a wide exposure latitude which can accommodate exposure errors and handles subjects well which have an abnormal tonal range.

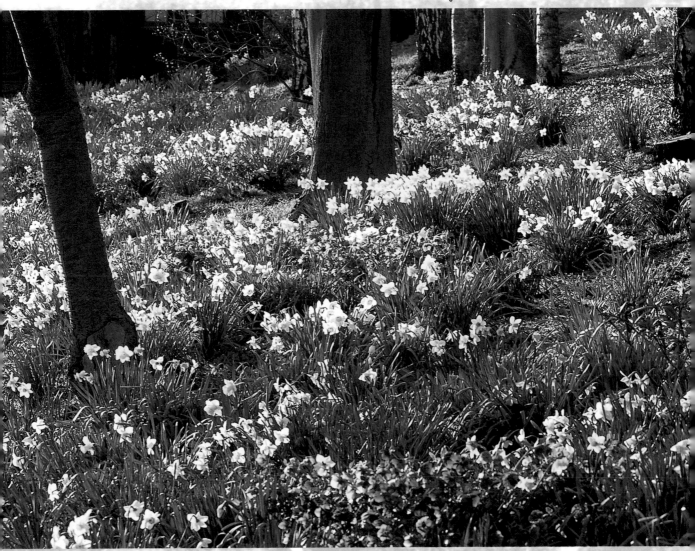

Technical Details
35mm SLR camera with a 75–300mm zoom lens; Fuji Super G 200.

Using Filters

Even in the best conditions, filters are essential, especially when shooting on transparency film, as even the brightest sunny day with the clearest blue sky and whitest of fluffy clouds can reproduce disappointingly unless every effort is made to get the very best from a scene.

Polarising filters

A polarising filter is, perhaps, the most useful of all filters because it can influence the colours in a scene selectively and does not alter the overall colour balance of the image. It is equally effective when used with colour print film, whereas the qualities created by a warm-up or neutral-graduated filter can easily be achieved when making colour prints from negatives.

While a polarising filter is mainly used for making blue skies a deeper colour, with white clouds standing out in stronger relief, it can have a much wider use than this. On overcast days it will often increase the colour saturation of foliage quite dramatically and produce much richer images. The effect on a spring or autumn garden scene can be very striking, for example.

A polariser can also help to give greater clarity when shooting distant views and is very useful for subduing excessively bright highlights when shooting into the light, like the sparkle on rippled water.

Polarisers need between one-and-a-half and two stops extra exposure, but this will be allowed for automatically when using TTL metering.

Marle Place, Brenchley, near Tunbridge Wells in Kent, UK.

Taken in high summer in the middle of the day with a deep blue sky and dense green summer foliage, it was necessary for Julien Busselle to use an 81C warm-up filter for this shot to avoid a very pronounced blue cast.

Rule of Thumb

As a general rule, when using a graduated filter to correct an excessively bright sky it's best to take the reading with the filter in place, but when using it to make clouds darker and more dramatic it is best to take the reading before the filter is fitted.

Technical Details
▼ 6 x 4.5cm SLR camera with a 55–110mm zoom lens; Fuji Velvia.

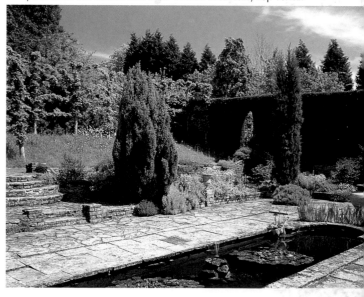

Hever Castle Gardens near Edenbridge in Kent, UK.

These two photographs demonstrate the effect which a polarising filter can have under the right conditions. In the image shot with the polariser the sky is much bluer, the cloud stands out in stronger relief and the colour saturation of the blooms and foliage is significantly increased.

▲ Technical Details
35mm SLR camera with a 80–200mm zoom lens; Fuji Velvia.

Other filters

Neutral-graduated filters are a very effective means of making the sky darker and revealing richer tones and colours. They can also **reduce the contrast** between a bright sky and a darker foreground, giving **improved tones** and colours in both.

Warm-up filters are essential to photographers shooting **outdoors** on colour transparency film as the colour temperature of daylight can increase far beyond that for which daylight film is balanced, especially on overcast or hazy days and beneath a deep blue sky in midday summer sunlight, when a pronounced blue cast will be created.

Rule of Thumb

With subjects that contain dominant areas of warm colours, like close-ups of yellow or orange flowers, it's best to be cautious with warm up filters as the effect can often be too extreme. There are occasions, too, when a natural blue cast can enhance the mood of an image.

Photographs For Pleasure & Profit

For most enthusiasts, the satisfaction of spending time in beautiful gardens and producing good photographs of them is a pleasure in itself, but it need only be the beginning of the benefits which this pursuit can bring.

Captioning

While a good photograph needs little further justification, images of subjects like gardens, plants and flowers can be given considerably greater interest and pleasure if the details of the photographs are recorded. And, of course, if you have ambitions to see your work in print, it is vital that your pictures are captioned accurately and filed efficiently.

The name and location of the garden is usually the prime category for photographs which have identifiable features, while for photographs of individual plants it can be useful to record the Latin name as well as its more common title, especially if you wish to submit photographs for publication.

Storing your Pictures

Card mounts are by far the most suitable way of storing and presenting colour transparencies. They can be printed with your name and address together with caption information. Added protection can be given by the use of individual clear plastic sleeves which slip over the mount.

The simplest way of storing mounted transparencies is in viewpacks – large plastic sleeves with individual pockets which can hold up to 24, 35mm slides or 15, 120 transparencies. These can be fitted with bars for suspension in a filing-cabinet drawer and quickly and easily lifted out for viewing. For slide projection, however, it is far safer to use plastic mounts, preferably with glass covers, to avoid the risk of popping and jamming inside the projector.

Presentation

When colour transparencies are to be used as part of a portfolio, a more stylish and polished presentation can be created by using large black cut-out mounts which hold up to 20 or more slides in individual black mounts, depending upon format. These can be slipped into a protective plastic sleeve with a frosted back for easy viewing.

Prints, whether black-and-white or colour, are most effectively presented either individually or perhaps with two or three compatible images mounted on a page in a portfolio. This can be in book form or as individual mounts in a case or box. For added protection it is possible to have prints laminated.

A light box, a powerful magnifying glass and a pair of sharp scissors are vital accessories for editing and mounting colour transparencies. The photograph shows pre-printed card mounts and caption labels protected by acetate sleeves and filed in a viewpack with a suspension bar for storage in a filing cabinet.

Editing

When selecting work for any form of professional presentation you must be very critical of your pictures. Transparencies need to be spot on for exposure and pin sharp – use a light box and a powerful magnifier to eliminate any which are sub-standard.

It is also best to be quite ruthless about eliminating any rather similar or repetitive images. Even for personal use the impact of your photographs will be greatly increased if only the very best of each situation is included and a conscious effort is made to vary the nature of the pictures.

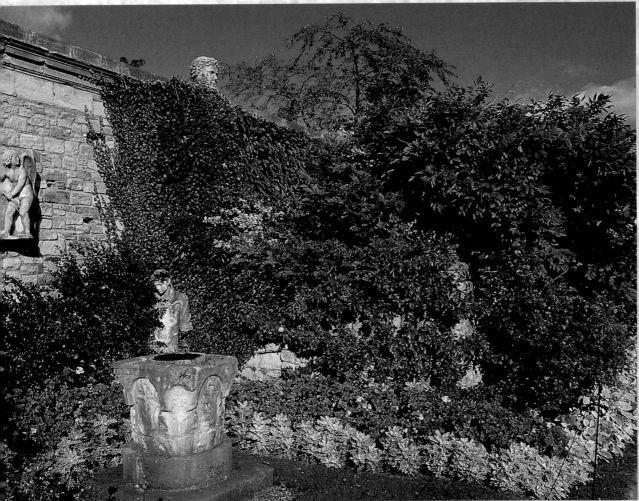

I have captioned this picture in the following way for my files: 'Hever Castle Gardens, near Edenbridge, Kent, UK... Italian garden in autumn with statues and ornaments, cinerarias and zonal pelargoniums.'

Photographs For Pleasure & Profit

Technical Details
▼ 6 x 4.5cm SLR camera with a 55–110mm zoom lens; Fuji Velvia.

Selling Your Work

There are a number of ways of finding a potential outlet for your work. Good photographs of plants and gardens are in constant demand by publishers of specialist magazines and books, of which there are a large number, and there is a ready market for most subjects if the photographs are well-executed.

Researching the Market

Spend some time in your local library, or newsagents, and see how the photographs are used in such publications and what type of image they prefer. Make a note of some names, like the editor, features editor and picture editor.

There are some useful reference books available which provide a general guide to potential users like the Freelance Writers and Artists Handbook and the Freelance Photographers Market Handbook, but it's best to study each publication before you make a submission.

Books and magazines represent only a small proportion of the publications which use photographs of flowers and gardens. Other potential outlets include travel brochures, calendars, greetings cards, packaging and advertising.

Winkworth Arboretum near Godalming in Surrey, UK.

Although photographed in a landscape format this image was cropped satisfactorily to be used as the magazine cover in the accompanying picture, an advantage of the greater image quality of medium format. But it's best to remember to shoot upright images with full-page and cover photographs in mind.

This photograph shows a small selection of the many ways in which flower and garden images are regularly used in a wide variety of publications.

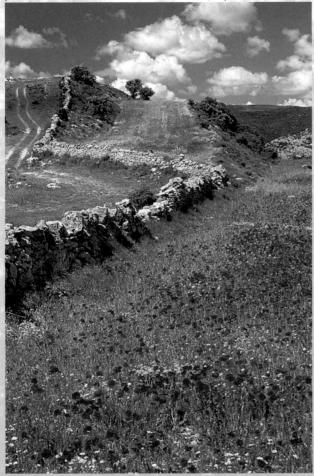

A poppy field near Teruel in the Maestrazgo region of Eastern Spain.

This image has been reproduced numerous times for purposes ranging from travel brochures to advertising leaflets, greetings cards and magazine covers.

Illustrated Articles

While good individual photographs presented to the right publication stand a good chance of being used, a complete package of words and photographs will stand a stronger chance. Many smaller magazines have limited resources and a clearly-written article of a thousand words with a selection of informatively-captioned photographs, illustrating the gardens described, is a tempting proposition.

Photo Libraries

A good photo library can reach infinitely more potential picture buyers than is possible for an individual and can also make sales to the advertising industry where the biggest reproduction fees are earned.

Making a Submission

As a general rule, you will be expected to submit several hundred transparencies initially, and will probably be obliged to allow those selected to be retained for a minimum period of three years. Your selection should be ruthlessly edited as only top-quality images will be considered and you should make sure that no similar photographs are sent, only the very best of each situation.

Although a good photo library can produce a substantial income in time from a good collection of photographs, it will take as much as a year before you can expect any returns and most libraries prefer photographers who make contributions on a fairly regular basis.

Glossary

Aperture Priority
An auto-exposure setting in which the user selects the aperture and the camera's exposure system sets the appropriate shutter speed.

APO Lens
A highly corrected lens which is designed to give optimum definition at wide apertures. It is most often available as a better-quality long-focus lens.

Auto-Bracketing
A facility available on many cameras which allows three or more exposures to be taken automatically in quick succession, giving both more and less than the calculated exposure. Usually adjustable in increments of one-third, half or one stop settings and especially useful when shooting colour transparency film.

Bellows Unit
An adjustable device which allows the lens to be extended from the camera body to focus at very close distances.

Cable Release
A flexible device which attaches to the camera's shutter-release mechanism and allows the shutter to be fired without touching the camera.

Data Back
A camera attachment which allows information such as the time and date to be printed on the film alongside or within the images.

Dedicated Flash
A flash gun which connects to the camera's metering system and controls the power of the flash to produce a correct exposure. It will also work when the flash is diffused.

Depth of Field
The distance in front and behind the point at which a lens is focused which will be rendered acceptably sharp. It increases when the aperture is made smaller and extends about two-thirds behind the point of focus and one-third in front. The depth of field becomes smaller when the lens is focused at close distances. A scale indicating depth of field for each aperture is marked on most lens mounts and it can also be judged visually on SLR cameras which have a depth of field preview button.

DX Coding
A system whereby a 35mm camera reads the film speed from a bar code printed on the cassette and sets it automatically.

Evaluative Metering

An exposure meter setting in which brightness levels are measured from various segments of the image and the results used to compute an average. It's designed to reduce the risk of underexposing or overexposing subjects with an abnormal tonal range.

Exposure Compensation

A setting which can be used to give less or more exposure when using the camera's auto-exposure system for subjects which have an abnormal tonal range. Usually adjustable in one-third of a stop increments.

Extension Tube

Extension tubes of varying lengths can be fitted between the camera body and lens to allow it to focus at close distances. They are usually available in sets of three varying widths.

Fill-in Flash

A camera setting for use with dedicated flash guns which controls the light output from a flash unit to be balanced with the subject's ambient lighting when this is too contrasty or there are deep shadows.

ISO Rating

The standard by which film speeds are measured. Most films fall within the range of ISO 25 to ISO 1600. A film with double the ISO rating needs one stop less exposure and a film with half the ISO rating needs one stop more exposure. The rating is subdivided into one-third of a stop settings – 50, 64, 80, 100 and so on.

Macro Lens

A lens designed to focus at close distances to give a life-size image of a subject.

Matrix Metering

See evaluative metering.

Mirror Lock

A device which allows the mirror of an SLR to be flipped up before the exposure is made to reduce vibration and avoid loss of sharpness when shooting close-ups or using a long-focus lens.

Programmed Exposure

An auto-exposure setting in which the camera's metering system sets both aperture and shutter speed according to the subject matter and lighting conditions. It usually offers choices such as landscape, close-up, portrait and action.

Reciprocity Failure

The effect when very long exposures are given. Some films become effectively slower when exposures of more than one second are given. Doubling the length of the exposure no longer has as much effect as opening up the aperture by one stop.

Shutter Priority

A setting on auto-exposure cameras which allows the photographer to set the shutter speed while the camera's metering system selects the appropriate aperture.

Spot Metering

A means of measuring the exposure from a small and precise area of the image which is often an option with SLR cameras. It is effective when calculating the exposure from high-contrast subjects or those with an abnormal tonal range.